ROTTINGDEAN
THROUGH TIME
Douglas d'Enno

AMBERLEY PUBLISHING

IN MEMORY OF BOB COPPER (1915-2004)
FOLK SINGER AND WRITER

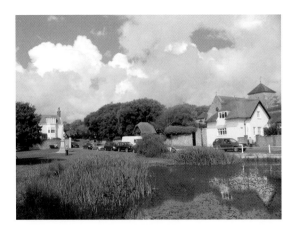

First published 2009

Amberley Publishing Plc
Cirencester Road, Chalford,
Stroud, Gloucestershire, GL6 8PE

www.amberley-books.com

Copyright © Douglas d'Enno, 2009

The right of Douglas d'Enno to be identified as the
Author of this work has been asserted in accordance
with the Copyrights, Designs and Patents Act 1988.

ISBN 978-1-84868-197-2

British Library Cataloguing in Publication Data.
A catalogue record for this book is available from
the British Library.

Typeset in 9.5pt on 12pt Celeste.
Typesetting by Amberley Publishing.
Printed in the UK.

Introduction

A number of books on Rottingdean have appeared over the years. To my knowledge there have previously been two pictorial volumes, both of which appeared in 1985 and both entitled *Rottingdean in Old Picture Postcards*. The authors were A. S. Payne/E. Scott and E. Ryman respectively. They were informative publications and some of the images in them inevitably reappear in this book, since postcards continue to be a rich source of local history images.

Rottingdean Through Time, however, is a first, differing in a number of important respects. It is based on 'then' and 'now' pictures and moves beyond postcards, thus affording the opportunity to introduce a number of unique images which are either in the author's own possession or have kindly been made available to him by Rottingdeaners and others. Some have long been stored in family albums and records and have never before been published. The contemporary photographs have, for the most part, been taken by the author and will stand in the future as a colourful record of the village and environs in the early years of the twenty-first century.

The intention of this volume, however, is not simply to portray time-contrasted buildings and scenes but also, where possible, to show people and events. We thus have a picture of St Aubyns School decked out for Queen Victoria's Diamond Jubilee, a number of photographs of the millennium procession through the village and an image recording the centenary celebration of the presence in the community of the Sisters of St Martha.

Surprisingly, some of the very recent history of Rottingdean has required more research and effort than was at first envisaged. For example, no picture was readily available of the building known as Littledean on Marine Drive which stood where some of The Cape apartments are located now. Fortunately, Brighton History Centre and Roedean School (the Rottingdean building was formerly the Roedean Mission) were able to assist.

The author was very fortunate to have access to two key items when preparing this volume: the album of Rottingdean pictures compiled over the years by the late David Baker of Ovingdean and a pre-publication copy of the comprehensive work, rich in historical detail, entitled *A Place-Name History of the Parishes of Rottingdean and Ovingdean in Sussex (including Woodingdean and Saltdean)* by Professor Richard Coates, a former Rottingdean resident.

It is hoped that this book will be found educational and entertaining and also afford some insight into the lives – at work and at play – not just of members of the prominent families for which Rottingdean is widely known but also of those simple, hardworking families who have been the backbone of the village down the centuries.

Rottingdean Through Time depicts not only people, buildings and scenes in photographs but also contains a chapter 'Rottingdean in Art'. The pages devoted to transport in the village, for their part, contain a number of surprising entries – some never before published in a book.

The author is grateful to Amberley Publishing for providing this opportunity to portray the village in so many contrasting, revealing and – in the modern images – colourful ways.

Douglas d'Enno
Saltdean, September 2009

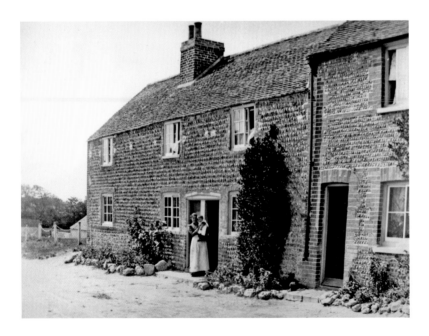

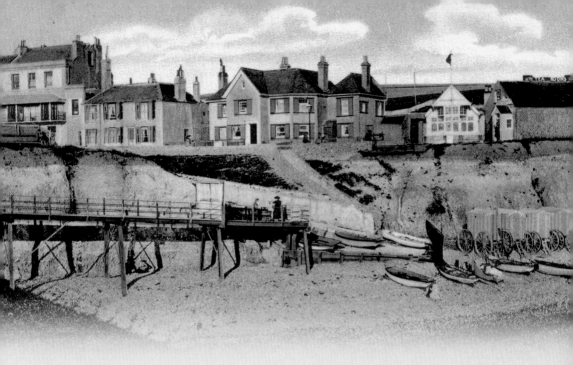

The Gap and Environs

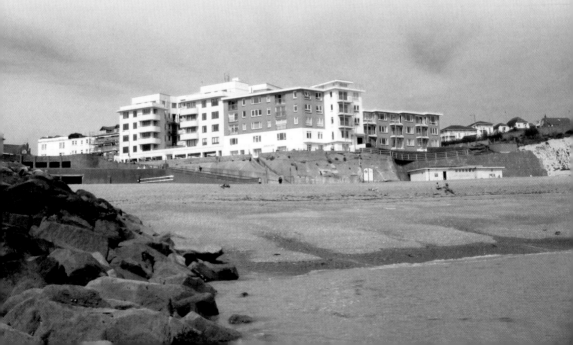

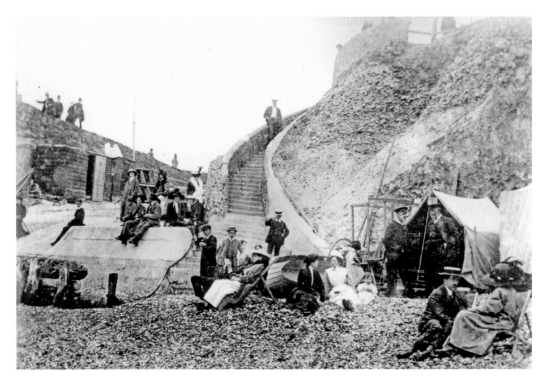

The Gap and Beach

On the previous page, the approximate location of the pier for Magnus Volk's *Brighton & Rottingdean Seashore Electric Railway* (1896-1901) has, since the early 1990s, been covered by a groyne built up of massive granite rocks.

At bottom right in the older photo on this page, Rudyard Kipling chats to his beloved Aunt Georgie (Georgiana Burne-Jones). In today's view of the same spot, the Undercliff Walk has supplanted part of the old beach area.

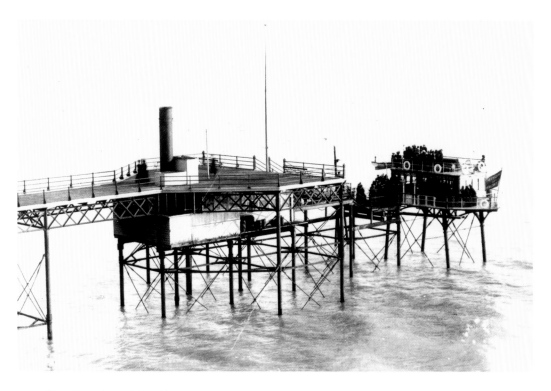

Two Foreshore Attractions

In around 1900, passengers board Volk's 'Daddy Long Legs', sea-going car, which is about to make the three-mile journey on its stilts to the Banjo Groyne in Kemp Town, Brighton. The steel pier was about 100 yards long. Power to the car was supplied by the generator in the box-like structure beneath its walkway.

The rocks are a magnet for both children and their parents today. No one heeds the notice prohibiting them from being clambered on...

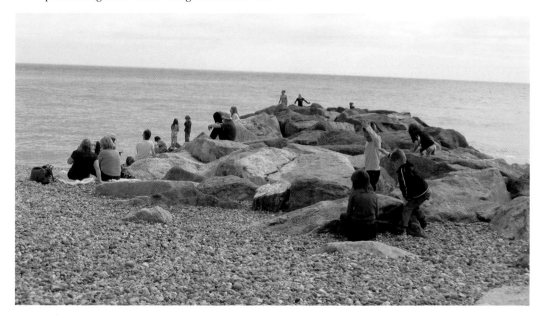

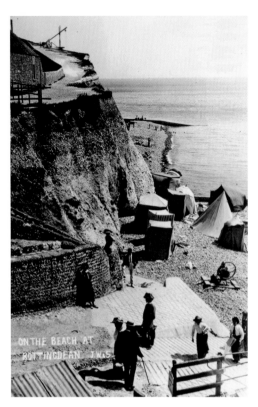

The Quarter Deck and a Lost Coast Road
'These are the little cotton tents from which we bath' [sic] wrote the sender of this postcard on 23 July 1913. A winch may be seen on the beach and a cliff crane in the distance. The dramatic fate of the building on the left, which fell victim to cliff erosion, is depicted on page 11.

Today, Highcliff Court, built in 1967, occupies much of the area known as the 'Quarter Deck'.

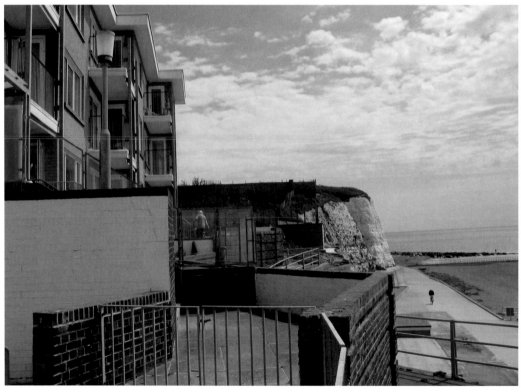

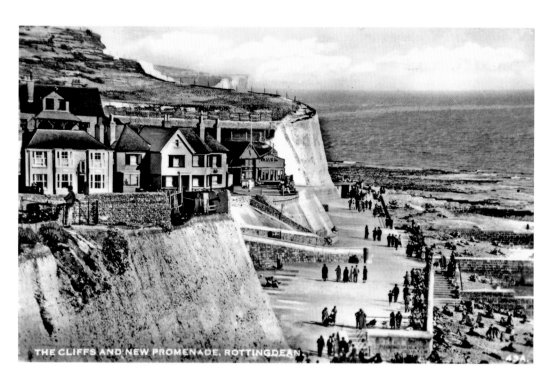

THE CLIFFS AND NEW PROMENADE, ROTTINGDEAN.

Two Eastward Views Contrasted

The prolific producer of postcards, A. W. Wardell, who operated from Brighton and Worthing, has left us this fine view, among many, of the cliffs, the 1930s Undercliff Walk and the beach. The building St Margaret's on the left would soon give its name to a large block of flats which would replace it in 1938. Part of it may be seen in the lower picture, abutting Highcliff Court. The groynes, access steps and promenade retaining wall have all disappeared.

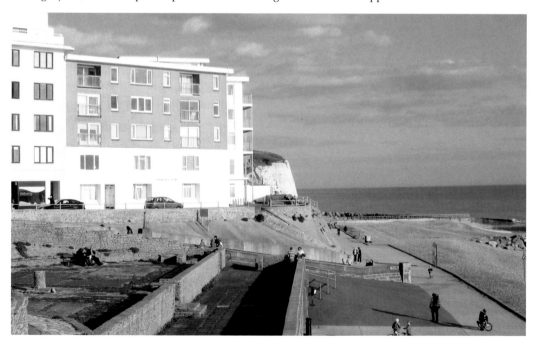

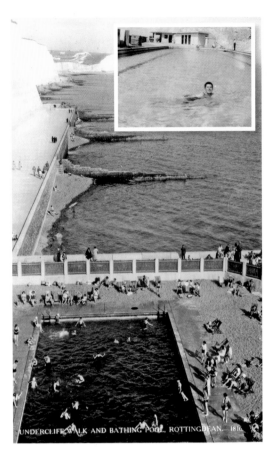

UNDERCLIFF WALK AND BATHING POOL, ROTTINGDEAN. 1816

The Lost Pool

Just east of the cliff headland in the previous picture once stood a flourishing swimming pool built as part of the Undercliff Walk. It was opened in 1934 when the Walk reached its eastern end at neighbouring Saltdean. The pool gave immense enjoyment to many for decades until 1995, when it was concreted over as part of major coastal protection works. (Inset: In the summer of 1946, young Maureen Smith has the pool to herself)

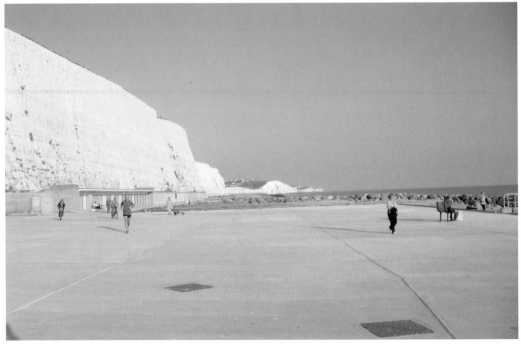

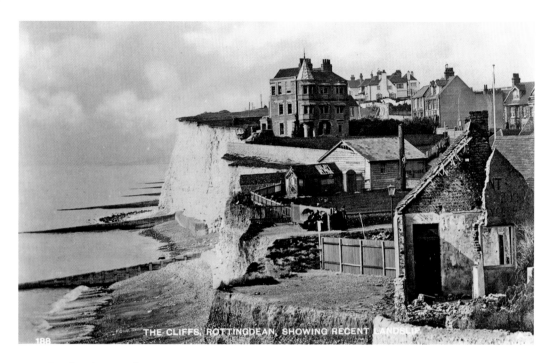

THE CLIFFS, ROTTINGDEAN, SHOWING RECENT LANDSLIP

Erosion Arrested

Turning westwards, we can see the devastating effect of erosion in another Wardell card dating from around 1914. The hut on the right had served as tea rooms. Another victim was the large residence in the distance, Cliff (formerly Cliffe) House, which partly fell over the cliff. The remaining structure was demolished, as it became a dosshouse for tramps. The Masthead Tea Rooms in the middle distance have also long since vanished.

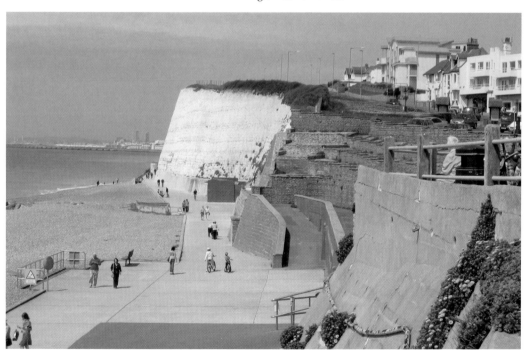

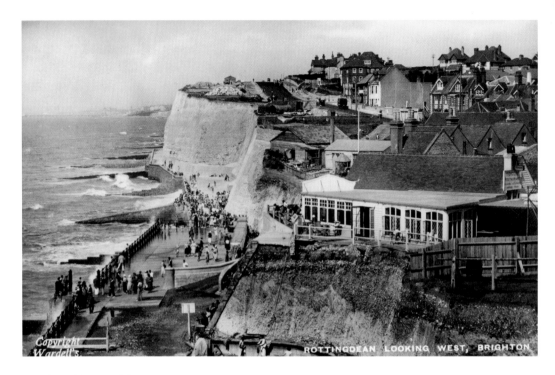

Another Westward Prospect

Wardell again records developments for us. The Masthead (centre) remains and the new Highcliff Restaurant on the right is doing good business. The view dates from before 1934, as there is no sign yet of the White Horse (see lower view) in its rebuilt form. The new Undercliff Walk is proving very popular indeed. The arrangement of groynes may clearly be seen, with Brighton in the distance. Work is evidently taking place on the coast road where it descends into the village.

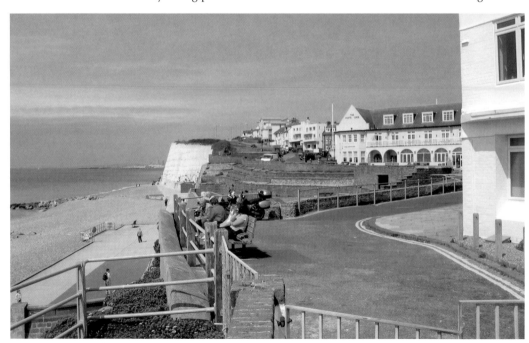

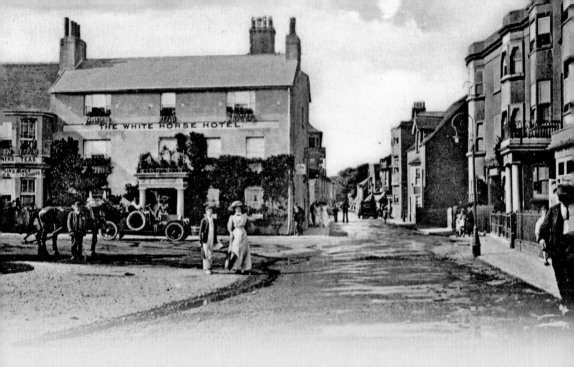

chapter 2

High Street (South)/Lower High Street (formerly Manor Terrace)

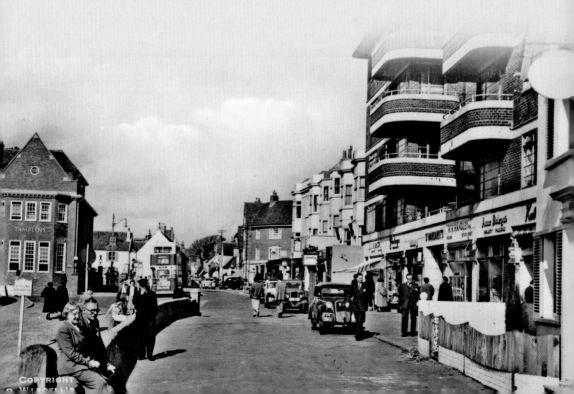

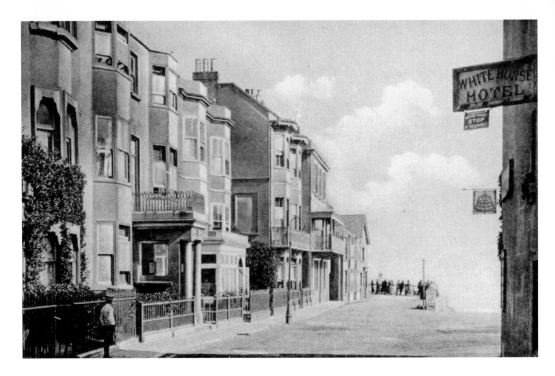

Looking Seaward

The preceding page contains two more Wardell cards – photographed from almost the same spot. The old White Horse Hotel was demolished in 1934 and rebuilt. The lower picture gives a good side-on view of St Margaret's Flats, erected in 1938. The protest against them prompted the formation of Rottingdean Preservation Society.

The above view of Manor Terrace shows the Star of the Sea Convent (with portico) on the left in 1919. Today's picture of this part of the village illustrates how popular and busy it is.

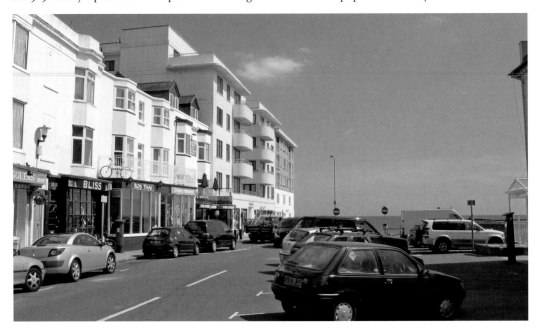

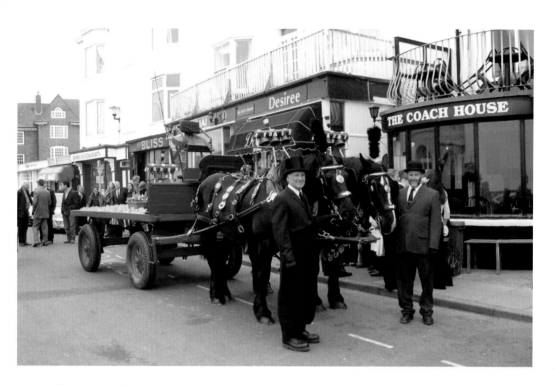

Village Farewell

To convey the coffin of Rottingdean-born folk singer and writer, Bob Copper, round the village on 17 April 2004, a trolley and horses were used. They were loaned by the late David Baker, a farmer from Ovingdean, seen here on the left. Also holding the horses, Diamond (left) and Chantney is Gus Kitson, a Suffolk farmer.

The small row of shops in the lower picture is only just visible in the modern photograph. Manor House, on the corner, fell victim to the scheme to widen the coast road in the mid-1930s. Demolition has already taken place on the south-east corner of the High Street.

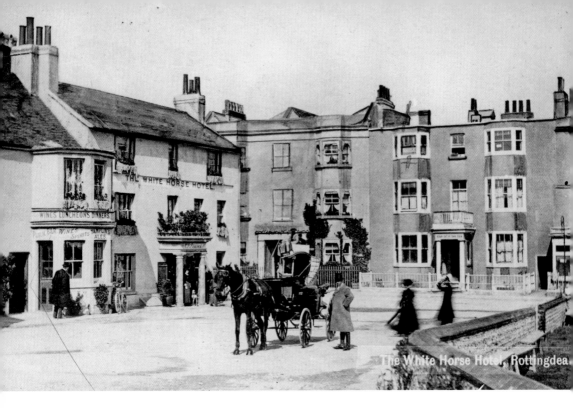

The White Horse Hotel, Rottingdea

The Old and New White Horse

The south frontage of the old White Horse Hotel, showing part of Manor Terrace viewed from the west. The White Horse has until recently always been a terminus for buses to and from Brighton, whether horse-drawn or motorised. The lower picture shows little major change to the former residential properties (including the Convent of the Star of the Sea) save for their ground-floor conversion to business use.

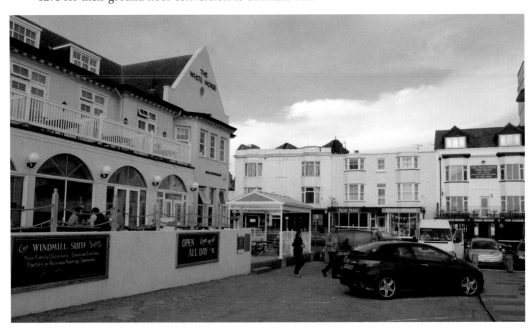

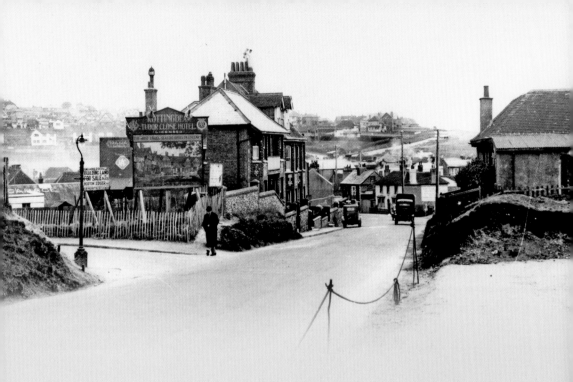

chapter 3

The Coast Road

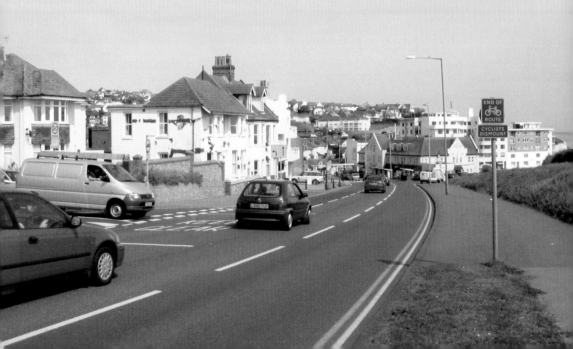

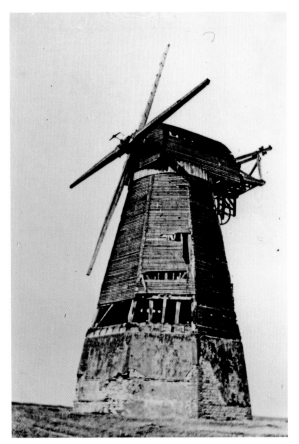

Kites Around the Old Mill

The hoarding advertising the Tudor Close Hotel places the date of the upper picture on the previous page in the early 1930s (Field Cottage, the white detached house down the hill on the right, was demolished in 1933). In the modern view, a van waits to emerge from Park Road.

Not strictly on the coast road but a few hundred yards to the north of it stands the old smock mill, seen here in a sorry state in around 1900. It had been erected a century earlier, specifically in 1802. It closed in 1881, the last miller in the village being one George Nicholls. Today, the structure is safeguarded and maintained by Rottingdean Preservation Society, which holds open days in the summer months.

These are sometimes combined with kite-flying events at which all are welcome. On a fine Sunday at the end of April 2009, little Sophia Hines, the author's granddaughter, takes a break from flying her kite to smile for the camera.

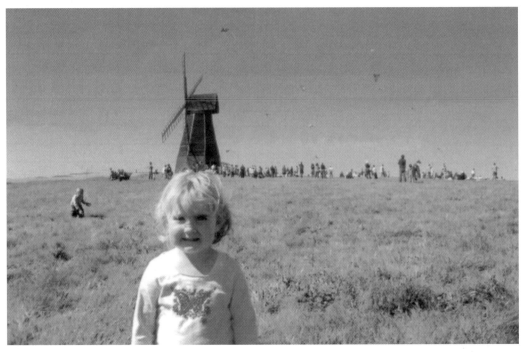

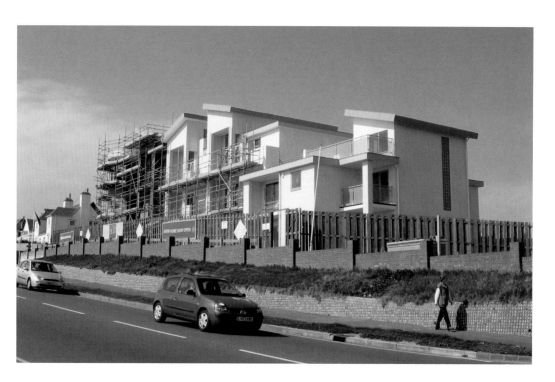

Many Homes from One

On Marine Drive, just west of the junction with Park Road, work is proceeding on the construction of the stylish Cape Apartments in April 2004. These stand on the site of the former Roedean Mission house for children, seen here in 1930 when newly-built.

In 1951, the Mission was wound up and the property sold. In the following year it was leased to Brighton Corporation and its name was changed to Littledean. It was eventually sold to Brighton Corporation in 1966.

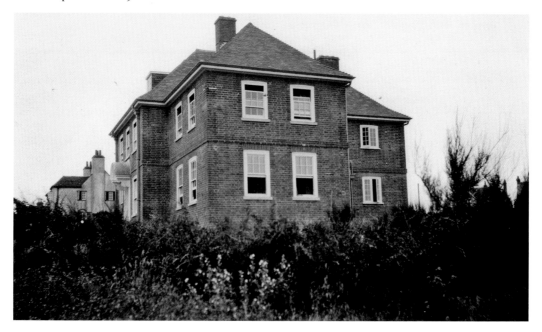

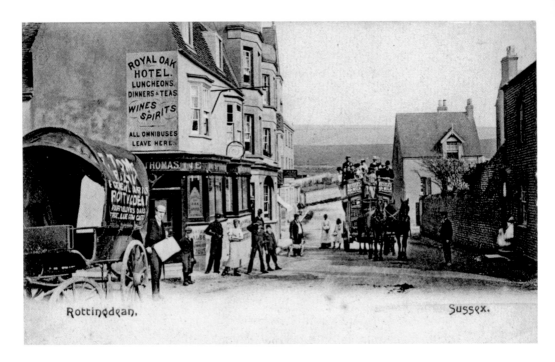

Rottingdean. Sussex.

Only a Flint Wall in Common...

Two postcards clearly showing the changes in the approach to the crossroads from the west. The Royal Oak Hotel had its own horse-bus service in the Edwardian era, operating in competition with that of the White Horse Hotel. The second view, by Wardell, dates from around 1960 and clearly illustrates the liberal parking on the Coast Road, the rebuilt White Horse and the housing on East Hill above St Aubyns playing field.

ROTTINGDEAN, BRIGHTON. 1183

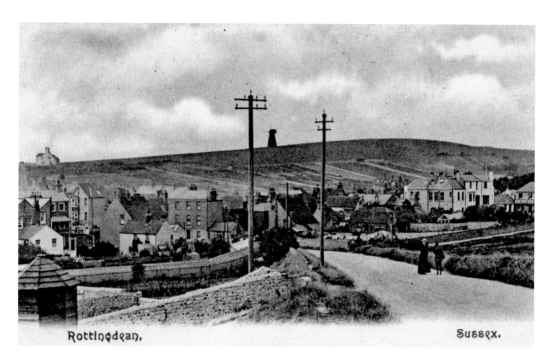

Rottingdean, Sussex.

Approach from the East

This more distant view of the village shows the windmill in isolation on the horizon. On the left in today's view, in front of the houses, is a clifftop car park owned by the Council (see p. 94), while on the right, part of the playing field of St Aubyns has been developed as St Aubyns Mead. The school itself can be seen on the right in the older picture.

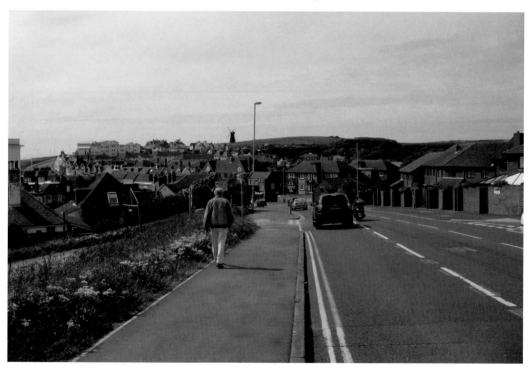

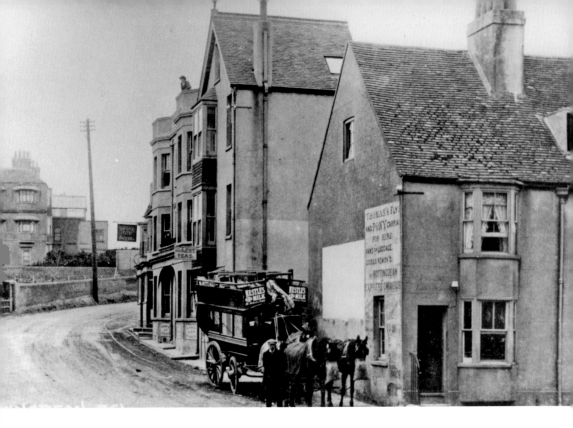

At the Crossroads

Here is a rare glimpse of the east façade of Cliff House (left), with the Royal Oak Hotel and a row of cottages on the right. The site is now a car park.

During the Millennium procession, Bob Copper (driving) and his family are at the crossroads about to head north up the High Street. The horses and trolley were loaned by the late David Briggs (he died the following year) from the Working Horse Trust in Eridge.

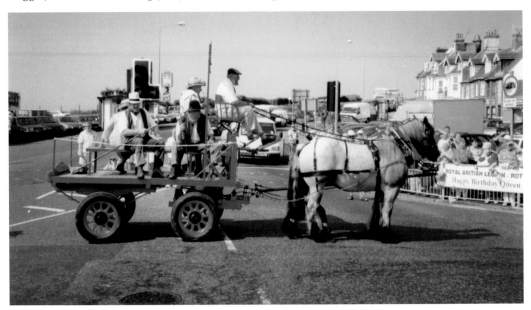

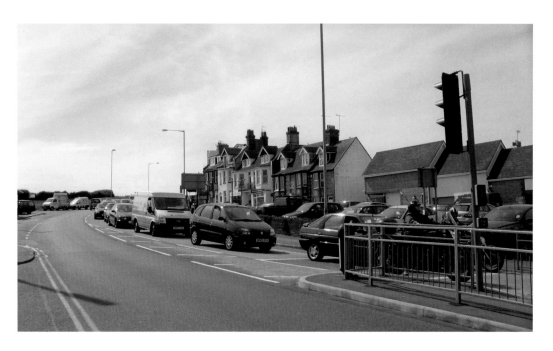

More Lost Cottages

The car park just mentioned can be seen behind the eastbound vehicles. A controversial bus-lane scheme introduced in 2008 has without doubt increased congestion for private vehicles entering and leaving the village.

Another loss from the 'West Street Triangle', in addition to those on the preceding page, was the row of coastguard cottages on the extreme right. Long gone also are the cliff-top properties behind the telephone pole.

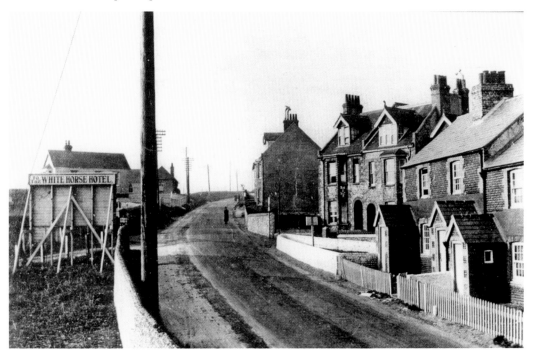

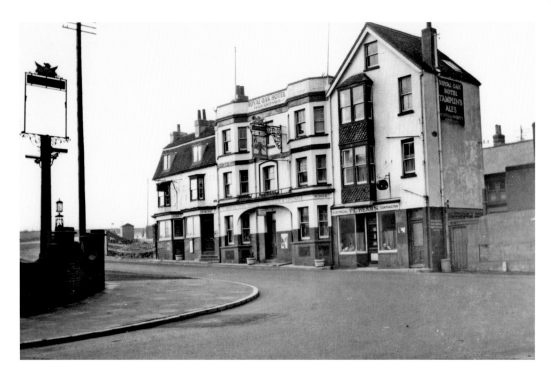

From the Imposing to the Mundane

On the left of this splendid and very rare view of the Royal Oak Hotel can be seen the site of the now-demolished coastguard cottages. The days of the hotel itself were therefore numbered. The undeniably useful car park may be clearly seen in the present-day view.

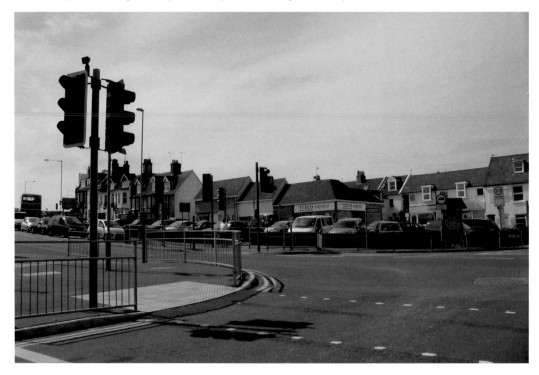

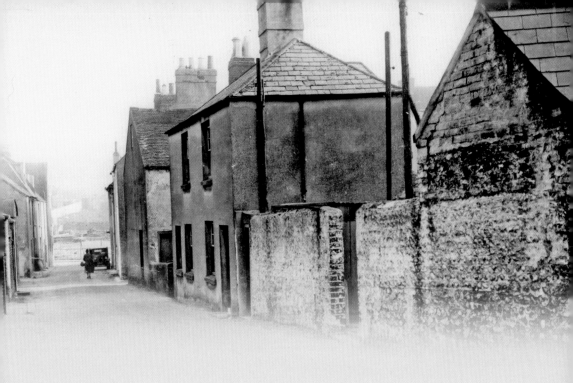

chapter 4

High Street (West)

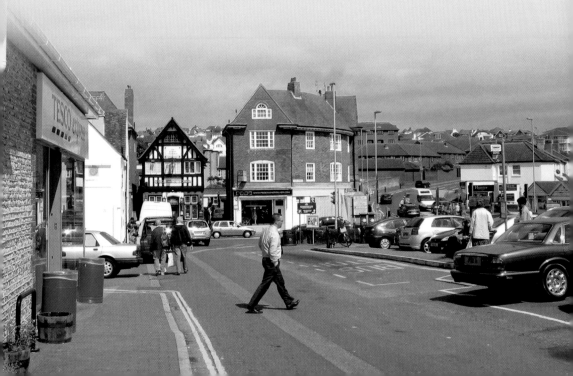

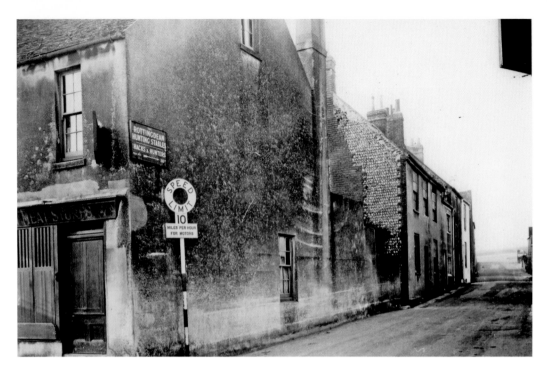

Big Changes on West Street

It is hard to imagine a greater transformation than that on West Street on the preceding page. Here we have the same view in reverse, looking west from the High Street. The doomed properties at the back of the triangle have been replaced by the car park. The hunting stables to which the visitor is directed were run by Jeff Boreham, who was killed early in the First World War.

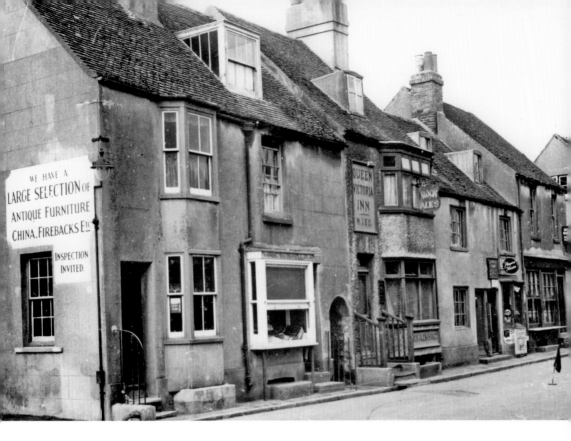

A Lost Parade

The sign for the stables is again seen here (far left). Behind it is the cottage whose south elevation can be seen so clearly in the view of the millennium procession from the crossroads. The old view shows O'Connell's fish shop and, next door, the Queen Victoria Inn, which lived on – in name at least – in a replacement public house of the mid-1930s across the street. Its Tudor-style frontage can be seen on page 25.

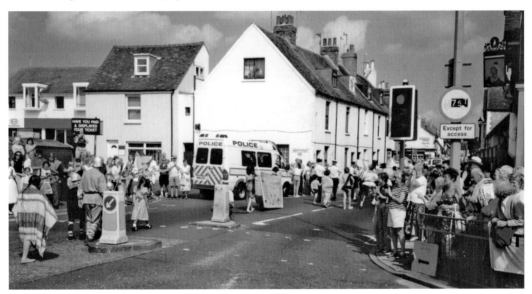

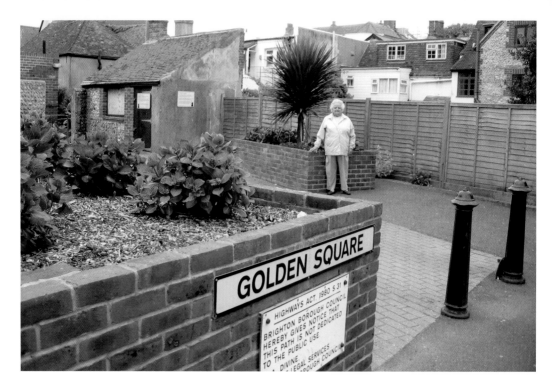

Golden Square

Tucked away behind West Street and the High Street stands Golden Square, much used today as a cut-through between West Street and Park Road. It once contained a row of four labourers' cottages, demolished in the 1930s. Born in one of these was Joan Snudden, whose Uncle Charles was, for a time, landlord of the Queen Victoria Inn. She still lives nearby. The old wash-house behind her was restored in 2002 as part of a joint project between Rottingdean Preservation Society and Rottingdean Parish Council.

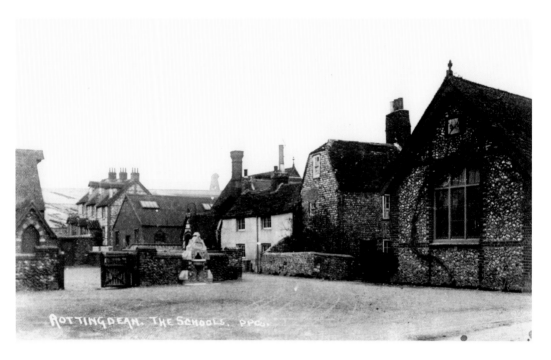

Nevill Road/High Street

Some way up the High Street is the junction with Nevill Road. On the corner (right) of the small square is the Reading Room of 1885-86, later a club room. On the extreme left is the entrance to the long-vanished National Mixed School of 1860. Across the road, further up, on the site known today as Laureen's Walk, is the Infants' School, next to a large tin building which was originally a laundry. It served as a chapel of ease for Rottingdean's Roman Catholics from 1918 to 1924.

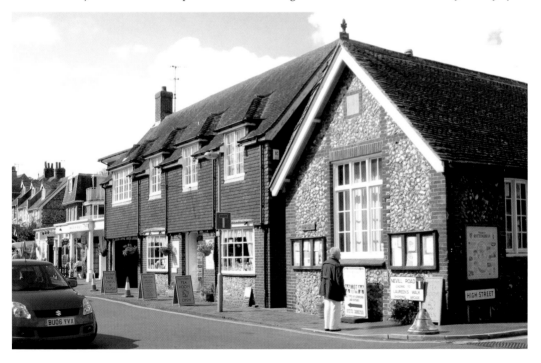

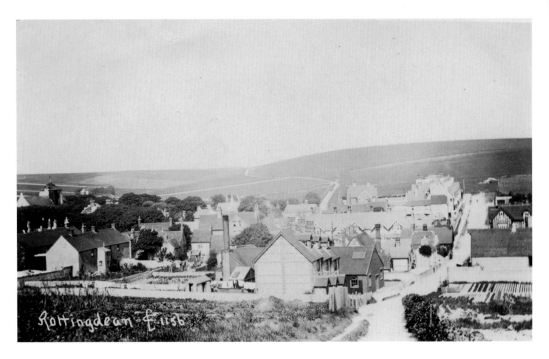

Looking down Nevill Road (1)

The view from the top of Nevill Road on this rare postcard of the early 1920s shows the tin chapel quite clearly at the foot of the hill. Next to it stands a row of cottages built in 1891, also visible in the modern view (one of them, No. 22, is the curiously named Bubble Cottage). A post office building and houses now occupy allotments and other open land on the right. Noticeable on the horizon is the spread of greenery near the ancient smugglers' track (Whiteway Lane) to Saltdean.

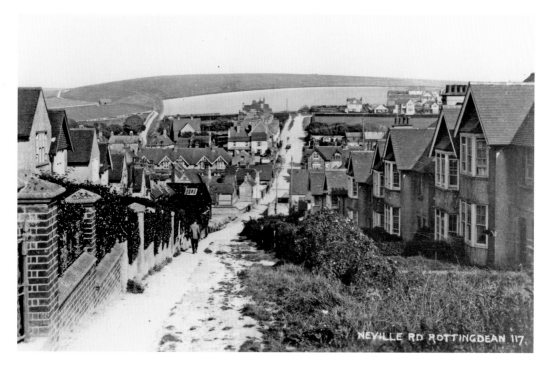

Looking down Nevill Road (2)

This similar view to that on the preceding page has been included to show the development of the south side of the road and because it depicts the Infants' School, with its walled playground near the former chapel of ease. The land on the eastern horizon was at this time undeveloped. Again remarkable is the growth of vegetation, both around properties and on distant downland.

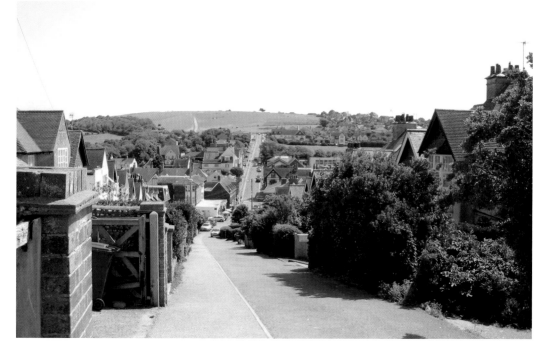

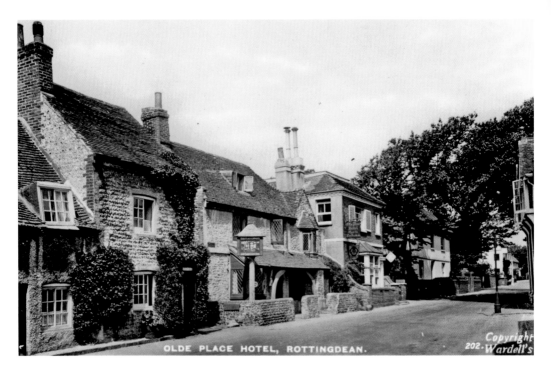

OLDE PLACE HOTEL, ROTTINGDEAN.

202. *Wardell's*

Copyright

Towards The Green

Another fine Wardell postcard, this time of properties at the northern part of the High Street. On the left are Hampton Cottage and Ivy Cottage. Next to them, the Olde Place Cottages and Smugglers' Den is a property merged from three earlier cottages. It is today the Rottingdean Club. The Olde Place Hotel is actually next door, displaying the RAC sign. It is now a private residence.

In the contemporary view, the colourful millennium procession wends its way towards The Green.

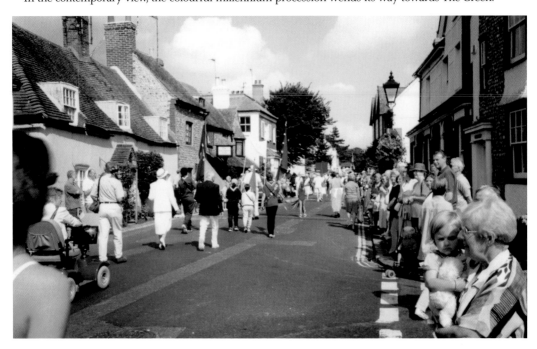

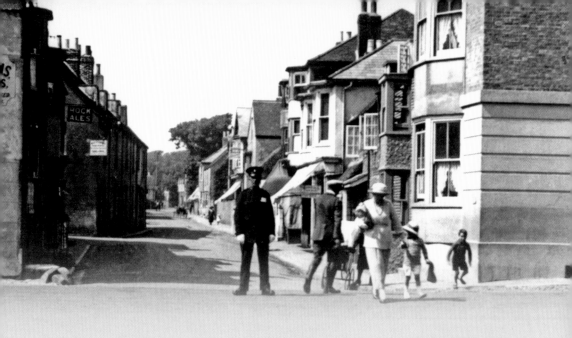

chapter 5

High Street (East)

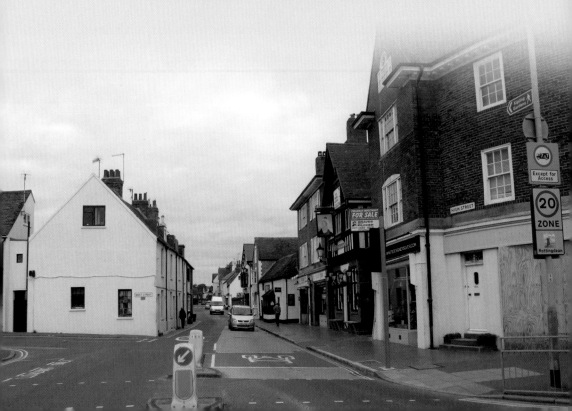

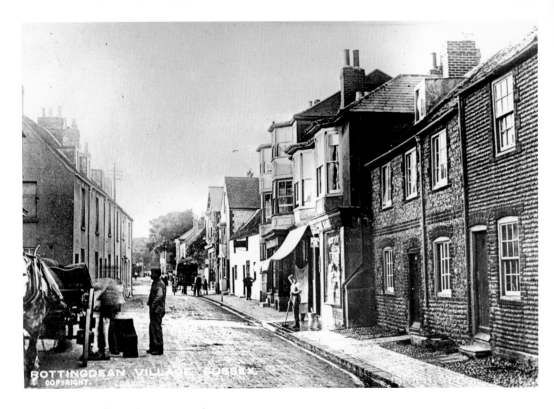

Looking North from the Crossroads

To the right of the policeman on point duty on the previous page was St Stephen's Holiday Home for (Invalid) Children, which occupied Stanwell House.

On this page, the animated, street scene postcard is a classic, although not rare 1930s buildings, including the relocated Queen Victoria public house, have supplanted the cottages and shops of yesteryear. The modern photograph of the crossroads almost bare of traffic could only be taken early on a Sunday morning!

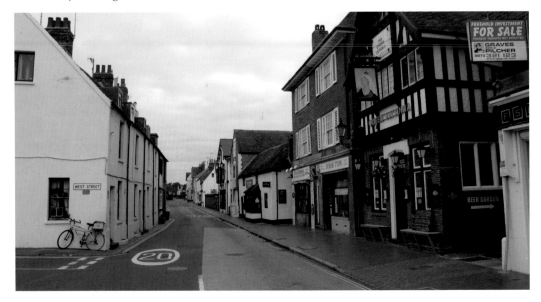

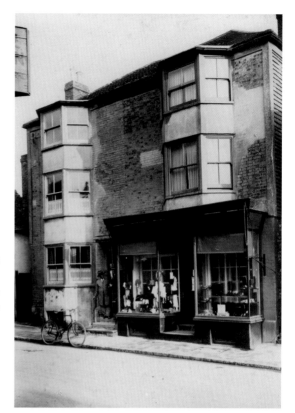

A Vanished Drapery Store and Residence
This view, from 1934, shows, from right
to left, Mary Richardson's drapery store,
the residence occupied by Ralph Cheale,
farmer, of New Barn Farm, and the
small alleyway which led to the back of
Mockford's shop (see overleaf). It was a
right-of-way for the two horses kept by
the customs officers who occupied The
Homestead, pictured on page 37, which
stood on the other side of the shop.

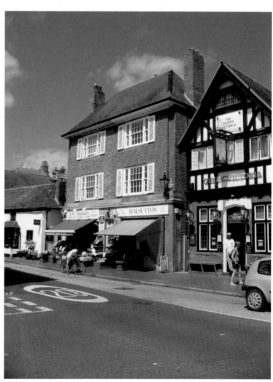

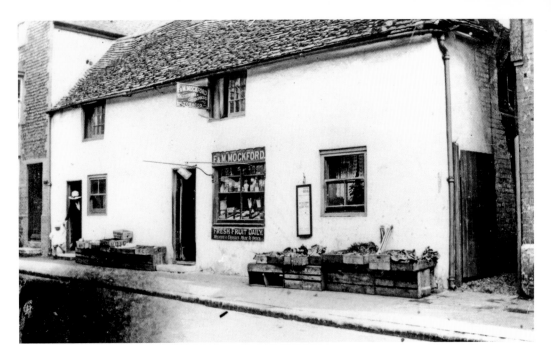

From Greengrocery to Tea Rooms

Like The Homestead next door (left), this property, which was formerly a greengrocery business run by Frank Mockford, has barely changed down the years. Dating from 1586, it is today the Olde Cottage Tea Rooms. Greengrocery is now available from the adjoining premises, Deveson's! In August 2001, over 100 descendants with the Mockford name gathered in Rottingdean to celebrate the first ever meeting of the Mockford clan.

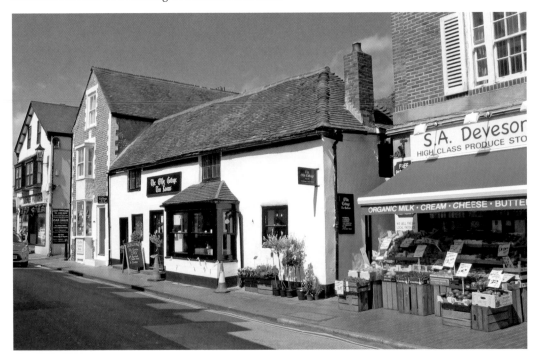

The Custom House/Tallboys

Apart from the removal of the lean-to structure on the left, the former Custom House, consisting unusually of three storeys, has perhaps seen the least change among properties in the village. Dating from 1780, it has borne several names: Tamworth House, The Homestead and, latterly, Tallboys. Until recently it housed a gift shop but lies vacant at the time of writing. The driveway on the left led to Dene Motors, a car sales outlet and garage currently awaiting redevelopment.

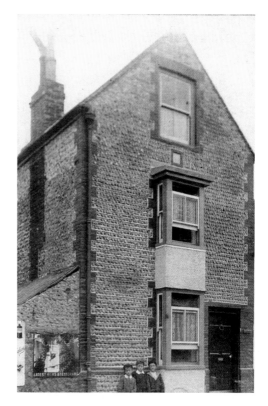

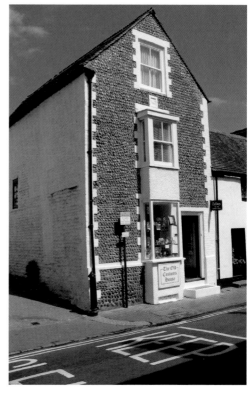

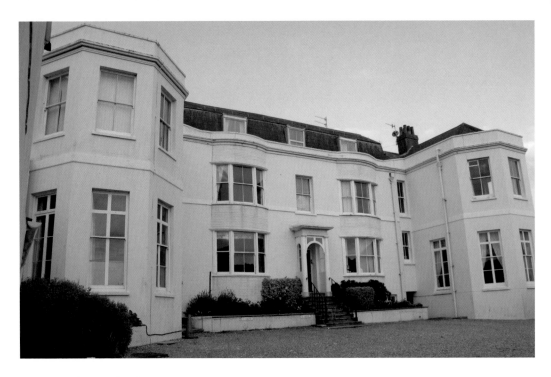

St Aubyns School

St Aubyns School, formerly Field House, was built in 1882. From 1887 to 1894 it was named Rottingdean School but that name transferred to a new establishment at the north end of the village (see page 48). Prominent former pupils of St Aubyns include John Kipling, the explorer and travel writer Sir Wilfred Thesiger and Nicholas Soames, MP for Mid Sussex.

In the lower picture, the school is celebrating Queen Victoria's Diamond Jubilee in style. At that time it lacked a south wing.

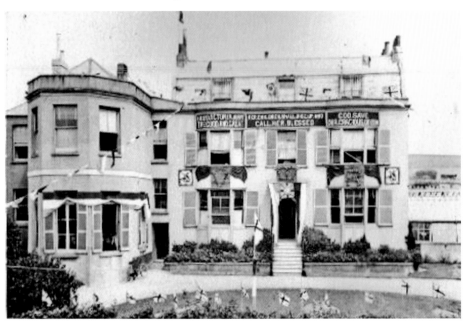

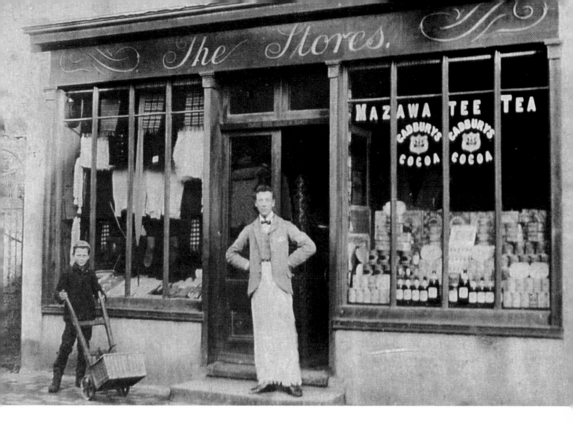

The Stores

A business that served the villagers for many years was The Stores. It opened under this name in 1918, and traded until 1962, having by then become Richardson's Stores (see next page). In the doorway stands Jimmy Cruse, the assistant in the shop. His son, Ron, later opened his own grocery business across the road, Cruse's Stores, which closed in 1979. A feature on these shops by this author appeared in the local *Weekend Argus* in April 2001.

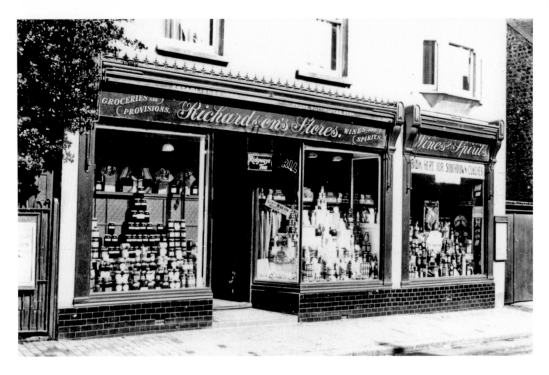

Richardson's Stores

'Old Mr Richardson', wrote Dulcia Stenning in her reminiscences of Rottingdean in the 1920s, was '... a typical grocer ... tall with silvery hair and glasses on the end of his nose.' Bob Copper, in Early To Rise, remembered him in his clerical grey alpaca jacket, moving 'gravely about from one job to the next'. Herbert Richardson had taken over the shop in 1923. His name was retained when the business was acquired by Ernest Penwarden three years later. It finally closed in 1962 under Penwarden ownership.

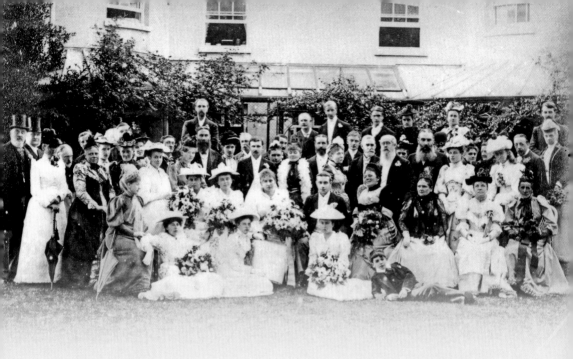

chapter 6

The Green and Beyond

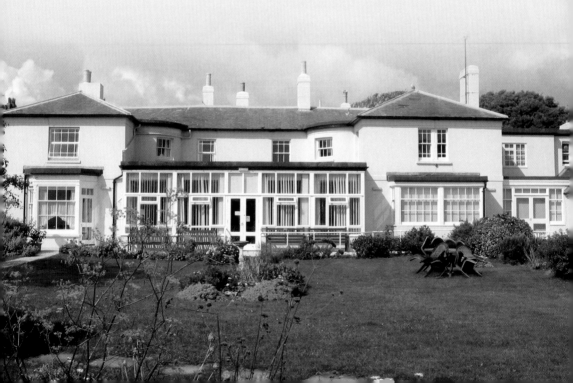

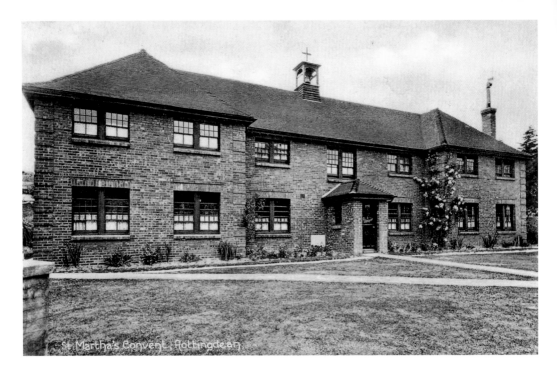

St Martha's Convent

The previous page shows The Dene of 1832 and a society wedding group in its grounds. Both the main house and annexe were converted to a sheltered housing scheme in 1975. The wedding, on 12 September 1892, was between Lucy Ridsdale (whose family owned The Dene) and Stanley Baldwin, a cousin of Rudyard Kipling, who would serve three terms as prime minister.

The Convent of St Martha dates from 1924. The procession marked the centenary of the order's arrival in Rottingdean in 1903.

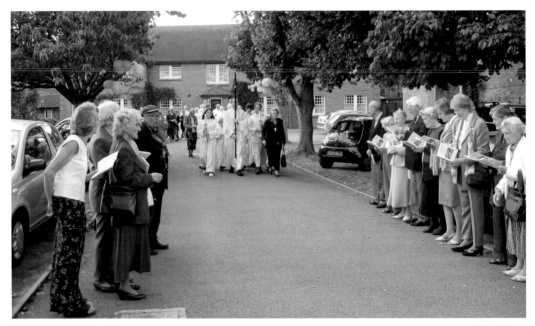

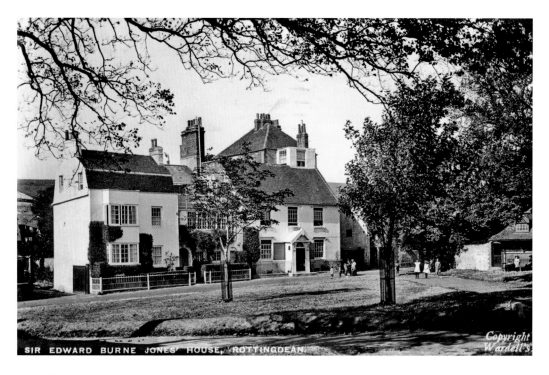

SIR EDWARD BURNE JONES' HOUSE, ROTTINGDEAN.

Copyright
Wardell's

Three Houses

These famous properties were the inspiration for Angela Thirkell's autobiographical *Three Houses* (1931). North End House (left) was originally Prospect House, purchased by Sir Edward Burne-Jones in 1880. He then acquired Aubrey Cottage next door and combined the two properties. On the right stands Gothic House, added to the already enlarged North End House in the 1920s by the authoress Enid Bagnold and her husband Sir Roderick Jones, the couple having moved to Rottingdean in 1923. The houses are now once again three separate residences.

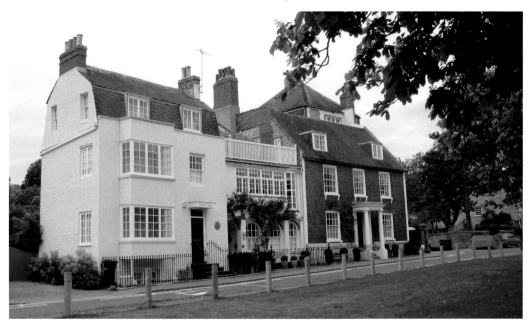

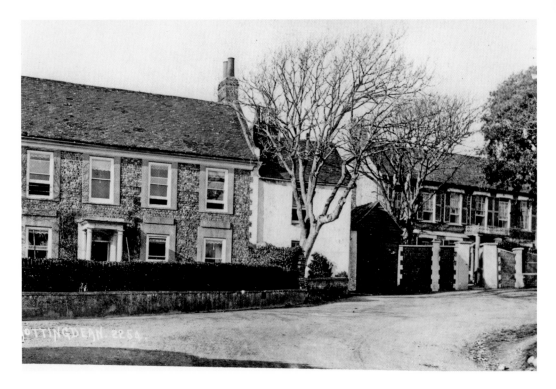

Down House and Court House

Just past the Hog Plat, with its track and allotments, stand the Georgian Court House and the seventeenth-century Down House, both with façades of knapped and squared flint. Court House was formerly the farmhouse of Court Farm, while its neighbour was, for 300 years, the home of the Beard family, owners of large areas of land locally. Today, the view of the property from the bend is completely obscured by tree growth.

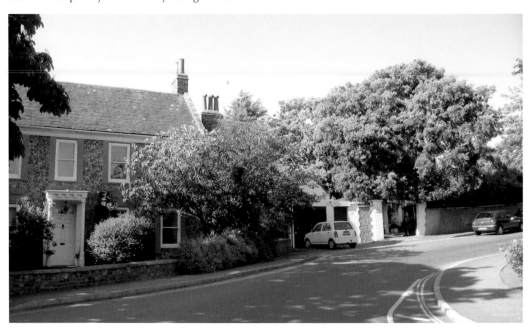

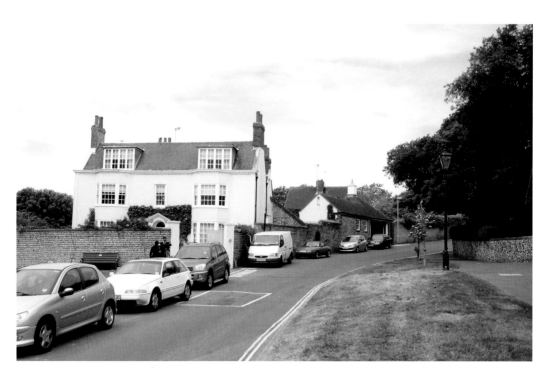

The Elms

Facing the village pond is The Elms, an eighteenth-century house whose claim to fame is having been the residence, from 1897 to 1902, of Rudyard Kipling. Its large garden was, in April 1986, saved from development by Rottingdean Preservation Society and later opened to the public as the Kipling Gardens. The churchyard of St Margaret's lies behind the flint wall on the right.

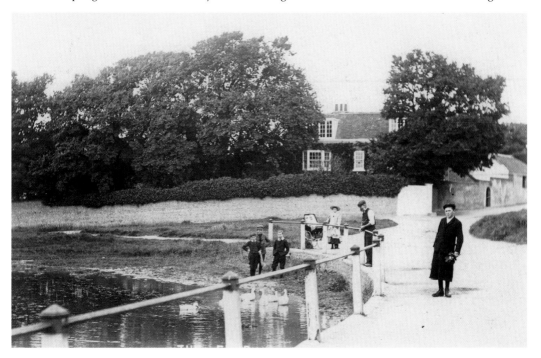

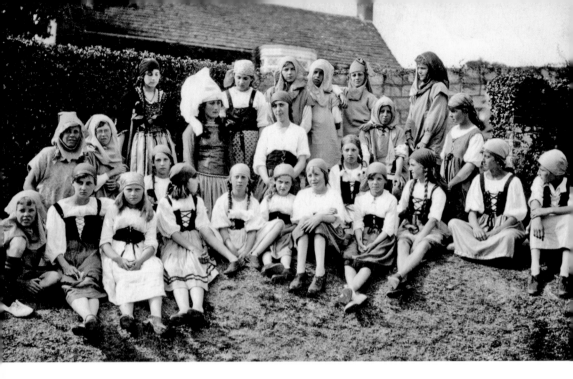

Challoners

In the early 1920s, pupils from the village's Public Elementary School performed *The Pied Piper of Hamelin* in the grounds of Challoners. Curiously, journalist and author Michael Thornton recalls being in a school *Pied Piper* production in the early 1950s at the same place.

Challoners, acquired by Thomas Challoner in 1456, is oldest house in Rottingdean. Altered in the late sixteenth century, it was – like Down House – the property of the Beard family for nearly 300 years.

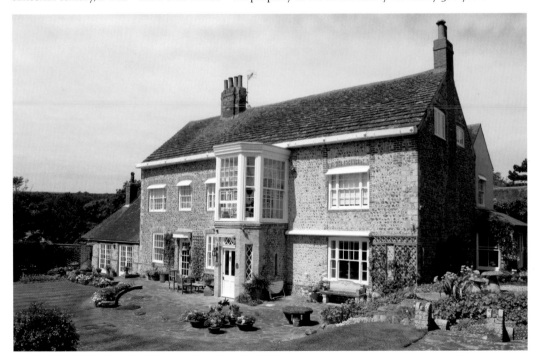

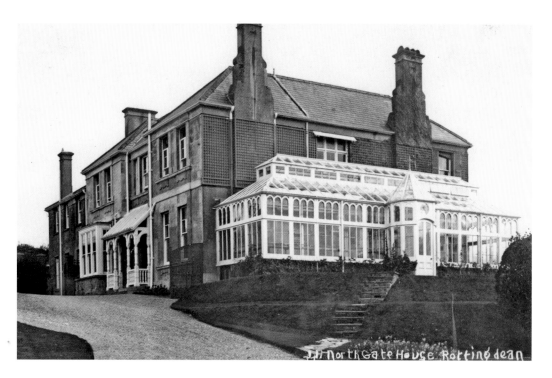

Northgate House

A few hundred yards away from Challoners stood Northgate House, first occupied, from the late 1880s, by one James Adamson, a St Kitts sugar magnate. In 1900, it was purchased as a country retreat by prominent lawyer and politician Sir Edward Carson QC MP (1854-1935), although, by 1914, he had given up the property. It was used in later years by the St Dunstan charity and leased to a school – Kenton Court – until demolition in the late 1970s. Today, Northgate Close occupies its site.

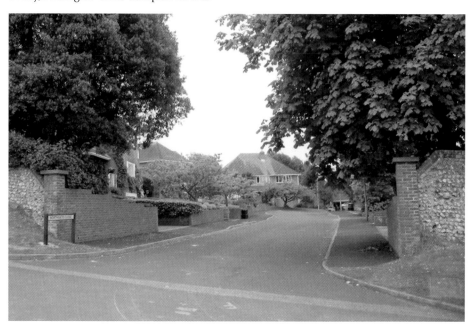

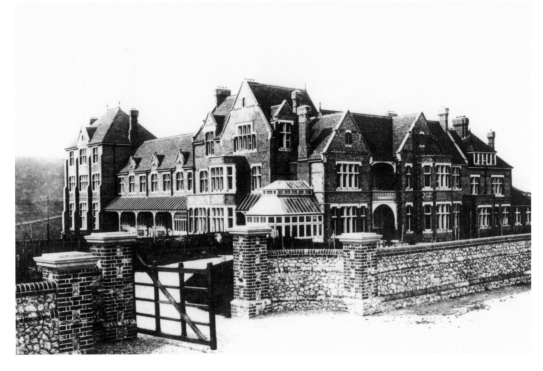

Rottingdean (Preparatory) School

This handsome school on the Falmer Road was demolished in 1964, having been partially destroyed by a fire in late 1962. It began life as an offshoot of St Aubyns in 1894. Two years later, pupils numbered sixty-four and staff eight. Notable former pupils include author and broadcaster Robert Kee and the Carey Evans brothers, grandsons of Lloyd George. Much of the site was developed in the mid-1960s as The Rotyngs. This author wrote a detailed article on the school for the *Weekend Argus* in July 2001.

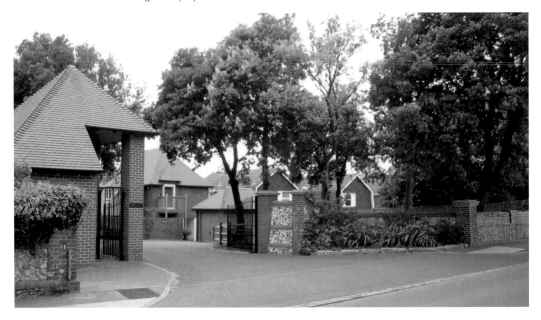

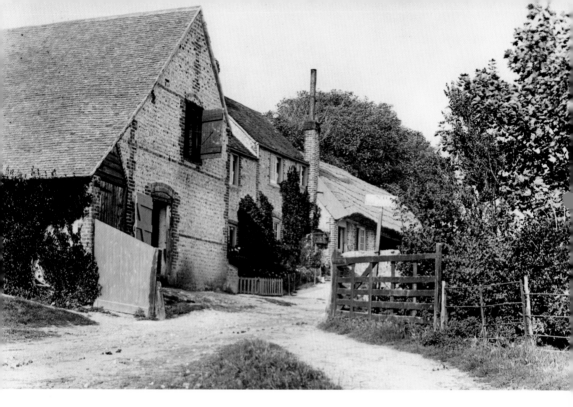

Tudor Cottages

The much-photographed 'Tudor Cottages' are not Tudor at all but skilful conversions of the tithe barn of Court Farm and some adjacent cottages carried out in about 1930 by Charles Neville, the developer of Peacehaven and Saltdean. The farthest cottage, combined with an open barn, had – unusually for coastal villages – a thatched roof. The barn was at the time of the early picture used as a stable by Jack Godden, carter to farmer William Brown.

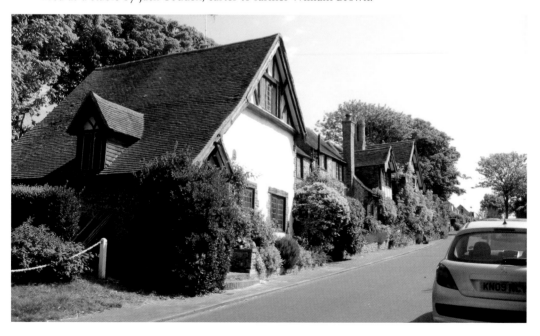

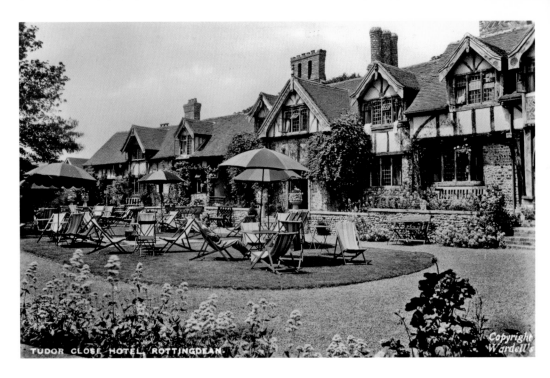

Tudor Close

Across the road an even more extensive 'Tudor' development took place – Tudor Close. Here too, farm buildings were transformed: two former barns and a cowshed of Court Farm. The seven original houses, completed by Saltdean Estate Company in the 1920s, did not sell well and were converted into the fashionable Tudor Close Hotel, which, in the 1930s, played host to many celebrities of the day. In the 1950s, however, the extensive property reverted to residential use in the shape of twenty-nine flats.

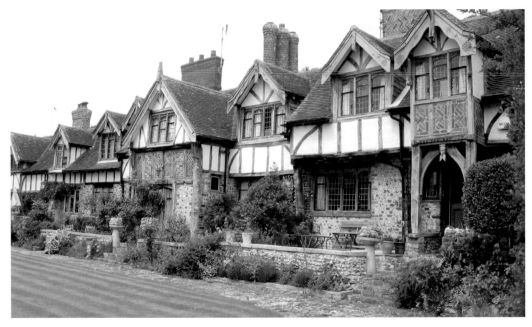

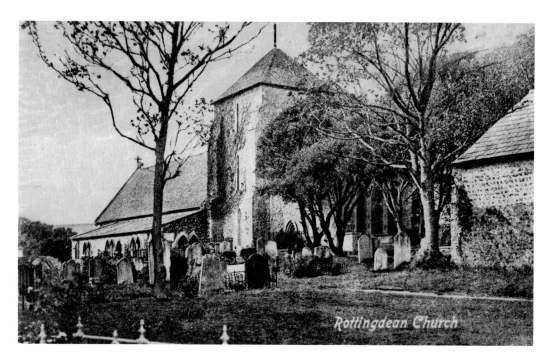

St Margaret's Church

St Margaret's Church stands on the site of an earlier Saxon church. In 1377, invading French forces set fire to the building, with a number of villagers trapped inside the tower. Seven stained-glass windows in the chancel and tower were made by William Morris from designs by Sir Edward Burne-Jones, whose three-light east window, representing the archangels, was installed in 1893 to commemorate the marriage of his daughter, Margaret, in the church.

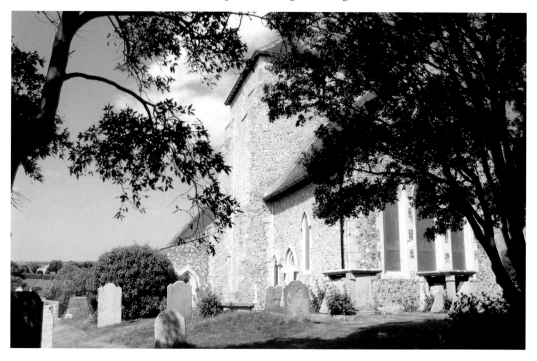

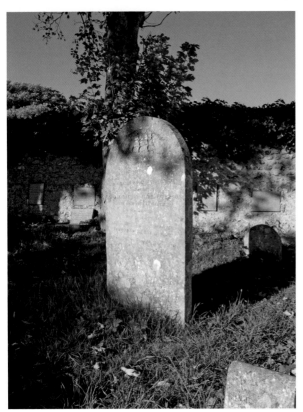

The *Eurydice* Tragedy

This mouldering headstone, in memory of four seamen, dates from 1878. It is interesting because their frigate, HMS *Eurydice*, a training ship, went down off the Isle of Wight on 24 March that year and their bodies drifted from the wreck as far as Rottingdean. Two remain unidentified. The other two are David Bennett AB and Alfred Barnes OS. The death toll was high, ultimately rising to 364 officers and men, most of whom were buried in the cemetery at Haslar Hospital in Portsmouth. A plaque in the town honours the memory of 317 of them: sixteen officers, 268 men, twenty-six marines and seven military passengers. Although the *Eurydice* was raised and brought into Portsmouth on 1 September 1878, she would never again be in commission and was broken up shortly afterwards.

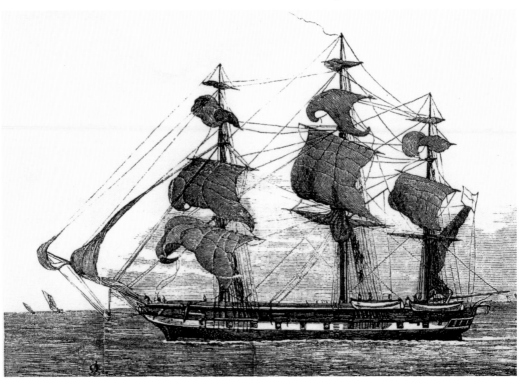

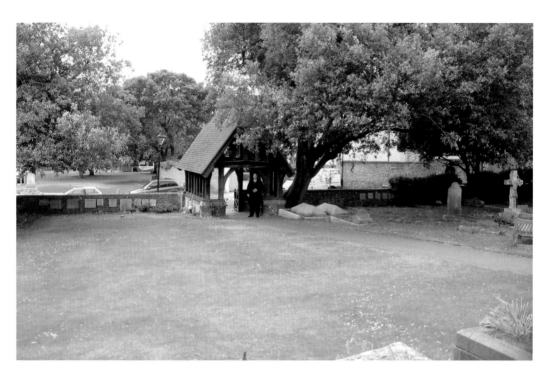

The Lych Gate

Rottingdean funeral director Christopher Stringer stands by St Margaret's lych gate, erected in 1897 in memory of the Rev. Arthur Thomas, vicar for forty-seven years. The remarkable tree growth to left and right now completely obscures North End House and The Elms. In the older picture, a low hedge surrounds the Ridsdale family plot close to the gate, while at far right in the foreground is the grave of the Scottish novelist William Black, who died in 1898.

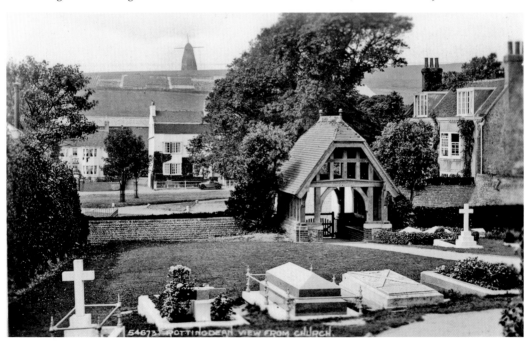

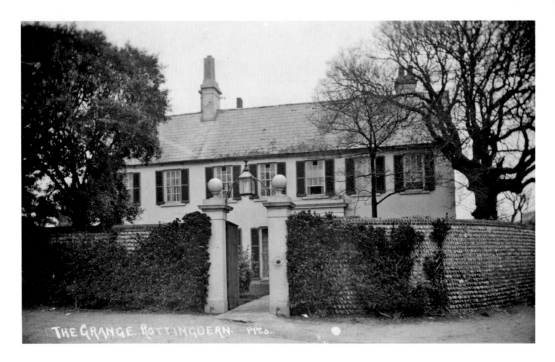

The Grange

This listed Georgian building dates from around 1740 and served as a vicarage until 1908. Its present name was given to it by the artist William Nicholson, who lived in the house from 1912 to 1914. In the 1920s, Lutyens restored the property for solicitor Sir George Lewis. Developer Charles Neville occupied it for some time. In 1953, the Corporation purchased The Grange and it now houses Rottingdean Library, a Rottingdean history room, a Kipling museum and an art gallery.

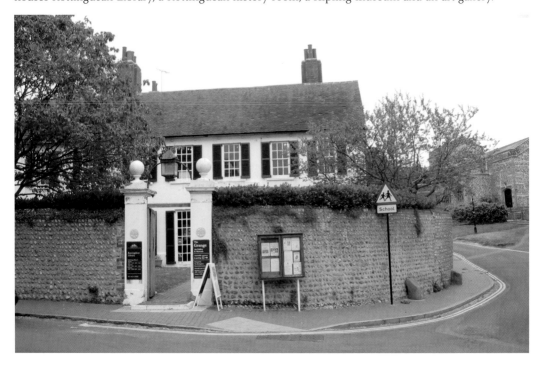

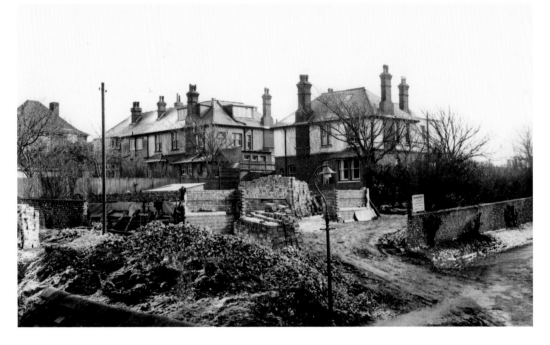

The Church of Our Lady of Lourdes, Queen of Peace

It is February 1956 and the garden of the property Eastfield (currently the presbytery) has been cleared as the site of the new Roman Catholic church. Some construction has begun, under the supervision of local builders Robert and Leslie Moppett. The splendid edifice opened its doors on 13 June 1957. The lower photograph is an unusual early view of the church.

This author's volume, *The Church in a Garden* (2001), provides a detailed history of both the church and the convent.

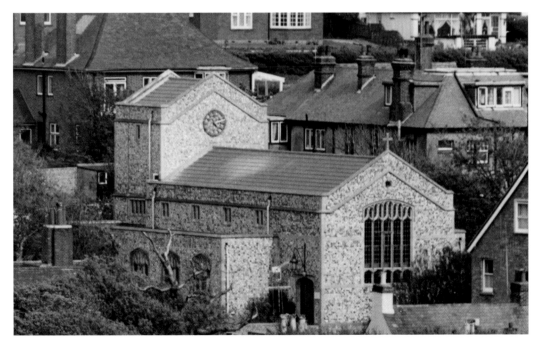

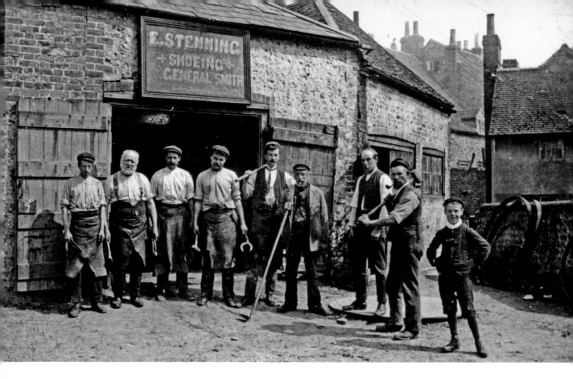

The Forge/Forge House, Vicarage Lane

This fine photograph of Ernie Stenning's smithy in Vicarage Lane, Rottingdean, was taken in around 1908. Ernie stands fourth from left. Second from left is Charlie Crossingham, who sold him the business (young Crossingham is at far right). Other members of village families (Moppett, Avis, Bowles, Sladescane, Hilder and Hilton) are in the line-up.

In 1972, despite fierce opposition, Forge House, six flats for ex-servicemen, was put up by the Elizabeth Dacre Housing Association on the site, by then 'a disreputable yard' (Betty Dacre).

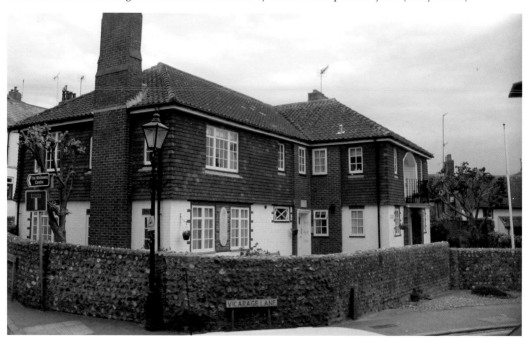

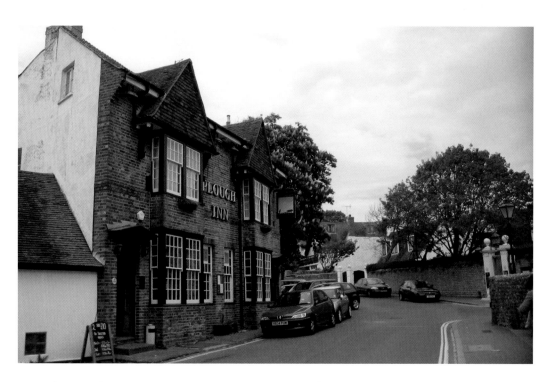

The Plough

Opposite Forge House stands the Plough Inn, dating from the 1840s but rebuilt at the turn of the last century and refaced in 1937.

The early view is thought to date from before 1900. In the main doorway stands the landlord, Edward Blaber, best remembered for his arguments with Kipling, especially on the subject of the South African war – arguments so violent as to endanger the publican's health!

See also the view on Page 66.

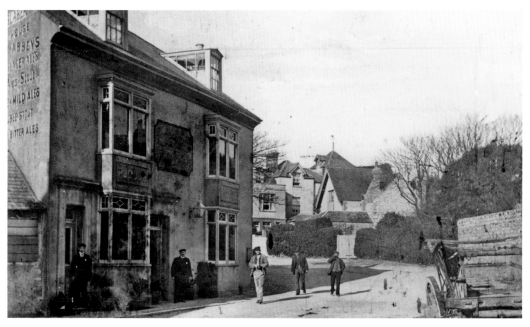

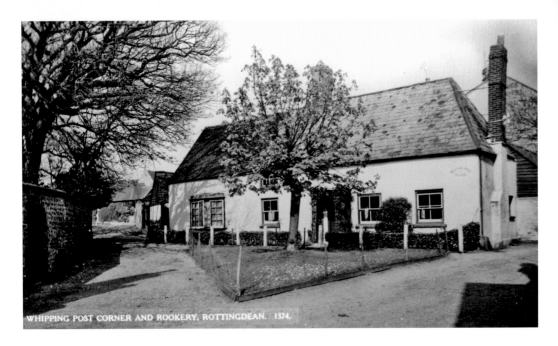

WHIPPING POST CORNER AND ROOKERY, ROTTINGDEAN. 1374.

Whipping Post House

Tucked behind The Plough is Whipping Post Lane. Its most famous residence is Whipping Post House, a listed building dating from the sixteenth century. It was once the home of Captain Dunk, village butcher by day and smuggler by night. Part of the property continued to serve as a butcher's shop in later years under William Hilder.

The flourishing chestnut tree stands on the spot once occupied by the whipping post for the punishment of miscreants.

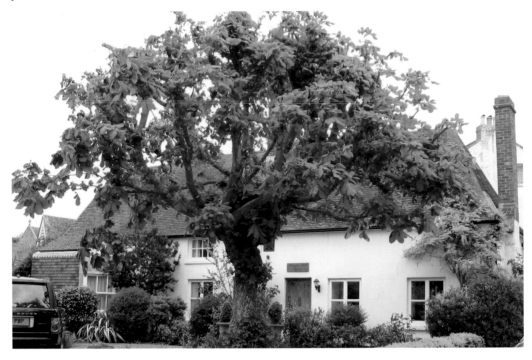

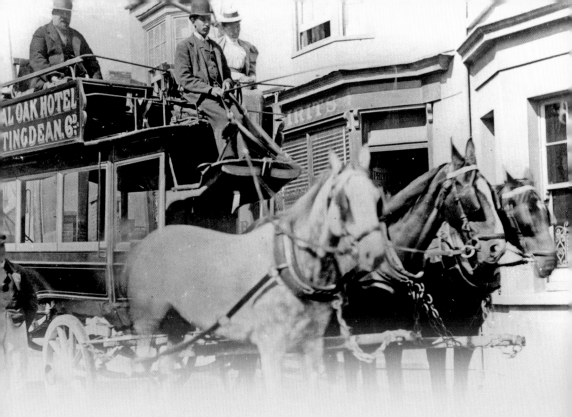

chapter 7

Getting Around

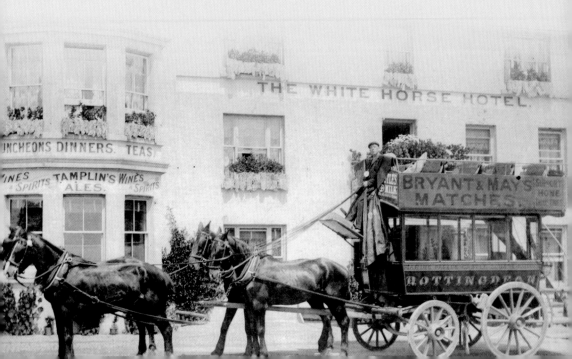

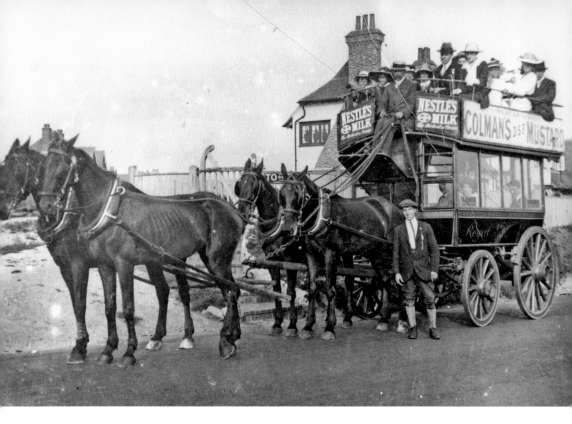

Village Horse Buses

Horse-drawn bus services were operated by two rival public houses, facing each other on the coast road: the Royal Oak and the White Horse (see previous page), whose landlords for many years were Frederick Thomas and Stephen Welfare respectively.

On this page, the Royal Oak bus is heading west from the village not far from the windmill, while Welfare's bus is standing outside St Margaret's church in around 1891.

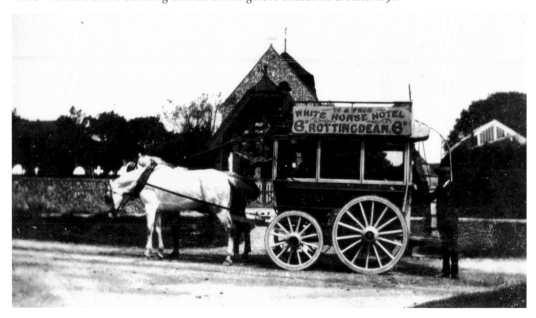

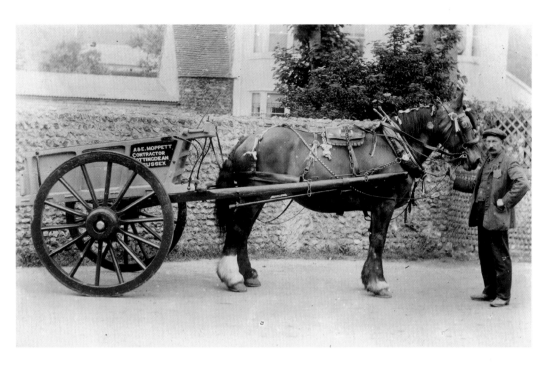

Moppett Carts

In these two pictures, horses are being used for private transport. Village publisher William Bowles produced the postcard of a horse and cart standing near Dale Cottage, near where Alfred and Ernest Moppett had stables. The man in the picture is an unknown employee.

The four-wheeled cart owned by the brothers is shown here being used for a family outing. Ernest is holding the whip and Alfred, smoking, is standing at the back. In the foreground stands Fred, another brother.

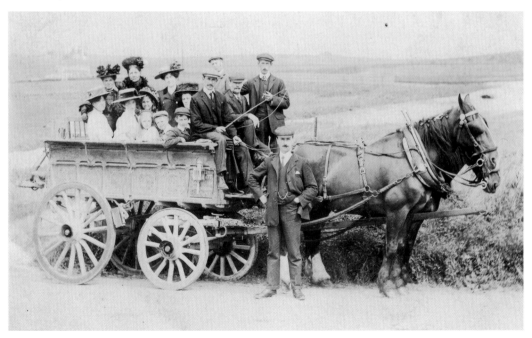

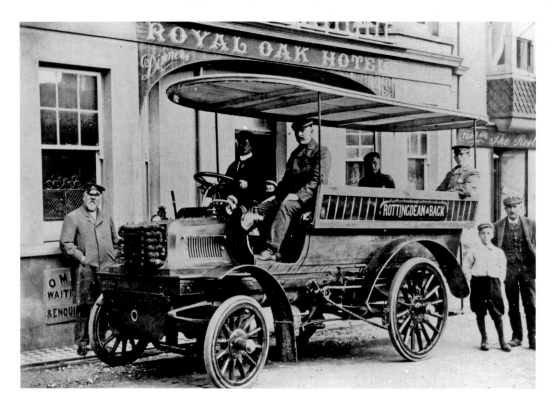

Motor Buses

A splendid view (top) of Frederick Thomas's 12hp Daimler 35-cwt Wagonette, thought to have been registered as CD 152 on 18 January 1904. It remained in service until 1912, running between Rottingdean and Brighton station. Frederick Thomas is standing in front of the vehicle and his son, George Frederick (1875-1956), is seated at the back (right).

In more recent times, the No. 7 double-decker waits in Manor Terrace, at the White Horse terminus.

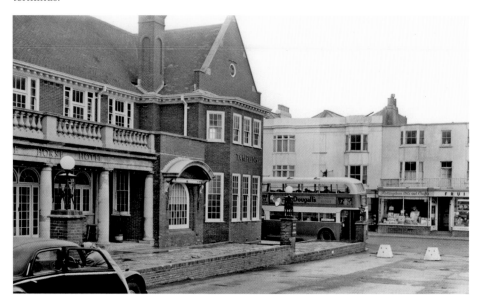

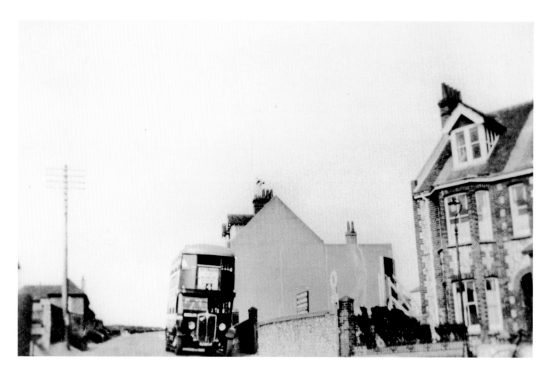

Contrasting Conveyances

The No 4 service double-decker, a Tilling AEC Regent, approaches its terminus from Brighton. The year is probably 1935, the last year of the company's operations in the Brighton/Hove area. On the cleared site behind the flint wall there now stands a block of flats with businesses on the ground floor.

This charabanc outside the White Horse Hotel was photographed after 1919, judging from the design of the AEC chassis badge, but no information is available as to the occasion or occupants.

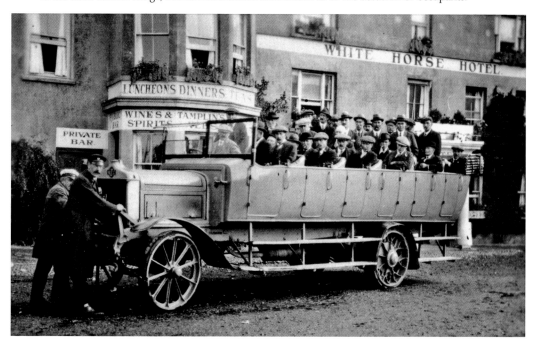

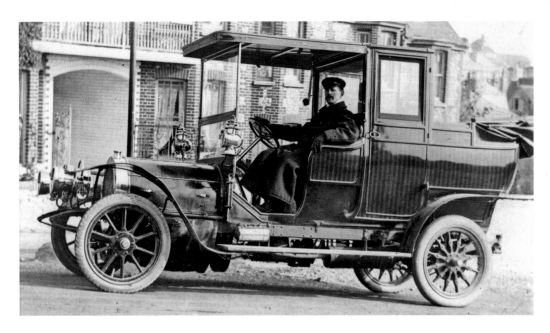

David Hennessy

Only a short distance away, Dave Hennessy, a driver from the village, sits in his rather fine Maudslay, possibly a 17hp model, fitted with landaulette-type bodywork. His first job was driving carriages and other horse-drawn vehicles for Fred Thomas, then he worked as a taxi-driver for Fred's son George.

In the second picture, Dave is near the White Horse, standing beside his Bean (possibly a 14) dating from the mid-1920s. The OT prefix was issued in Hampshire.

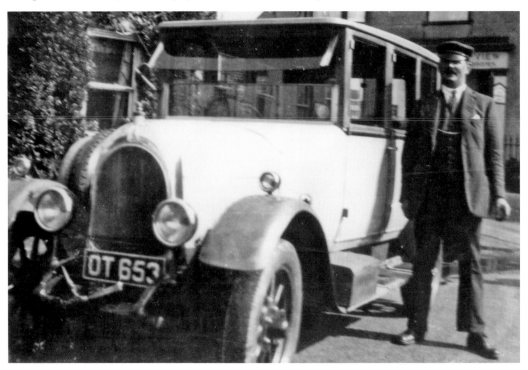

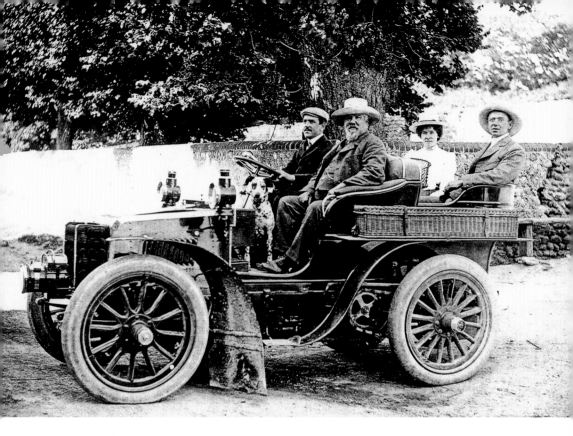

A Napier and a Morris

Charles Thomas (1880-1941), the son of Fred (in the front passenger seat) at the wheel of his Napier, which may be a 16hp model of about 1901. In a car like this he drove twice round the world in the company of his employer, the American millionaire Charles Jasper Glidden.

In complete contrast, young Harry Hilder is driving his flat radiator Morris (either an Oxford or a Cowley) on the Falmer Road on an unknown date, although post-1926.

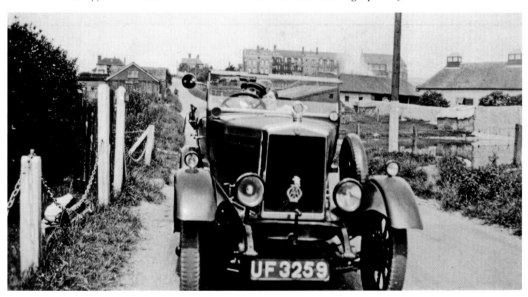

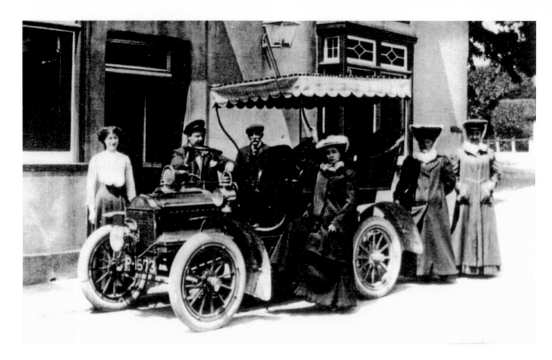

Another Contrast

This fine period piece depicts an Oldsmobile, probably a 10hp model of about 1904, outside the Plough Inn. A good number of American cars were being imported into Britain at this time. The P prefix was issued in Surrey.

Charles Moppett is being chauffeured in his own taxi on his wedding day. It is here seen turning west from the crossroads on the coast road.

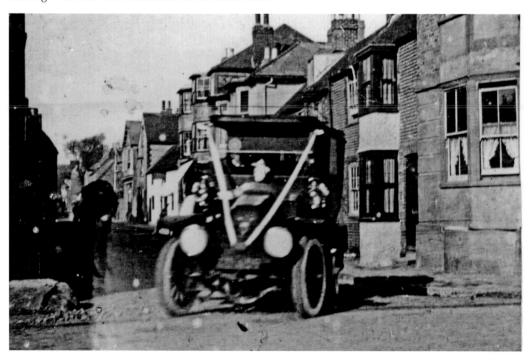

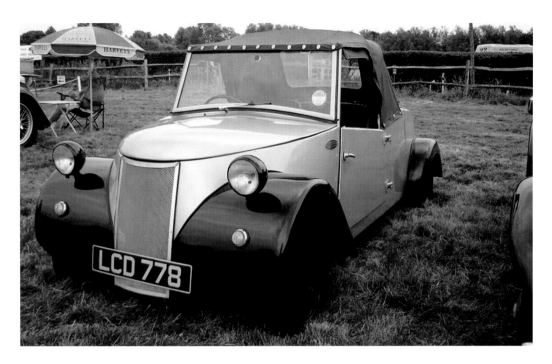

Pride and Joy Cars

A B.M.A. Hazelcar, beautifully restored by Saltdean resident Arthur Hazell. This vehicle was the brainchild of the brothers Eric and Roy Hazeldine of Rottingdean. Its owner from new was Sir Roderick Jones' son, Dominick, who clocked up over 50,000 miles in it between 1951 and 1957.

Winifred Hoyle is in the back seat of the Rolls-Royce owned by author and local historian Henry Blyth. The occasion was the 1994 Rottingdean Fair, with 'Nursery Rhymes' as the cavalcade theme, this entry being 'Goosey Goosey Gander'.

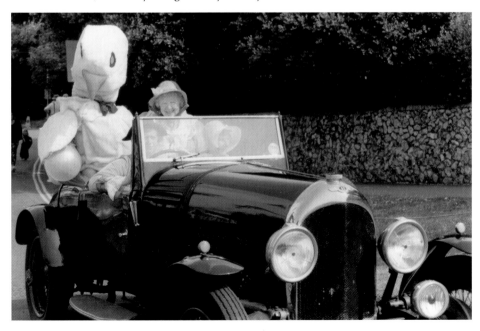

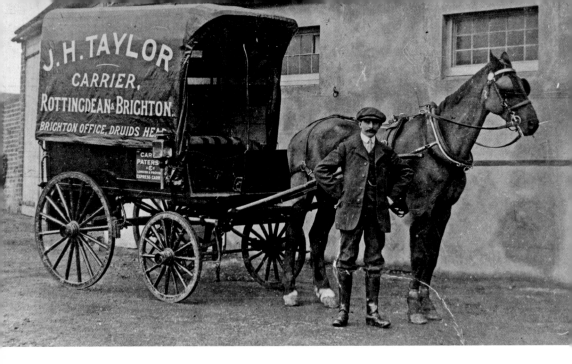

Transport by Taylor

James Henry Taylor (*b.* 1881) started as a bus conductor on Frederick Thomas' horse bus. After Thomas sold out to Tilling, Taylor bought a horse and cart and started his own carrier business. The cart was built by Arnold & Marshall of Jubilee Street, Brighton.

 JHT at the wheel of his first motor lorry, a one-ton Model T Ford with left-hand drive. The body was also built by Arnold & Marshall and was royal blue in colour.

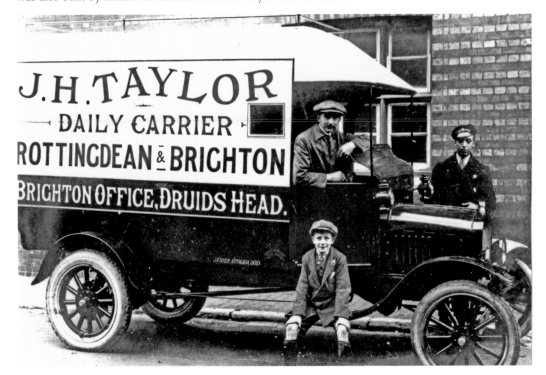

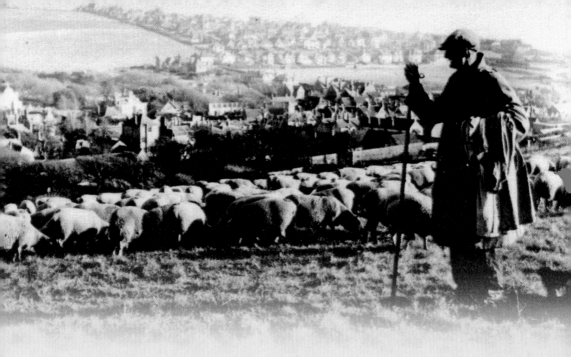

chapter 8

Farming and Hunting

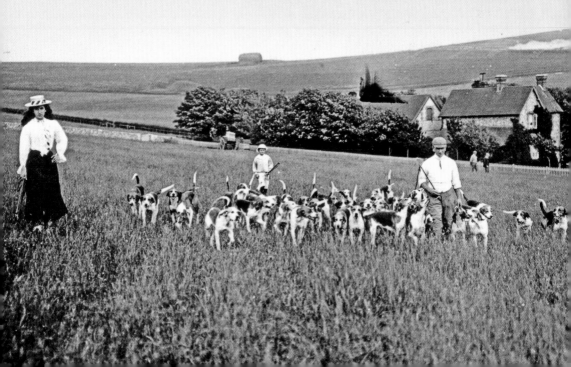

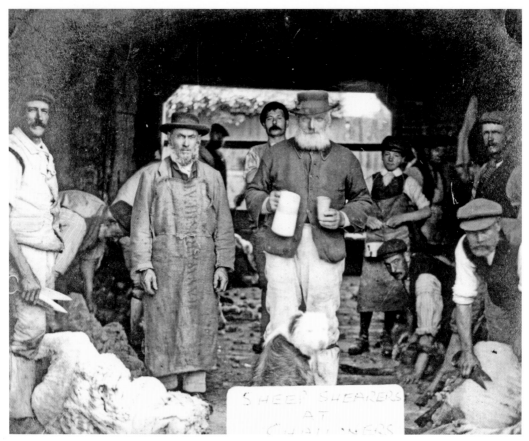

Sheep-farming Days

'The old shepherds', wrote Lucy Baldwin and Arthur Ridsdale in their *Annals of Old Rottingdean*, 'with their smocks and crooks – emblems of the South Downs and of their calling – were always picturesque', an observation borne out by the previous page.

Here we see the men engaged in shearing at Challoners while in the lower picture Bob Copper, who wrote so much about farming in this area, is in pensive mood.

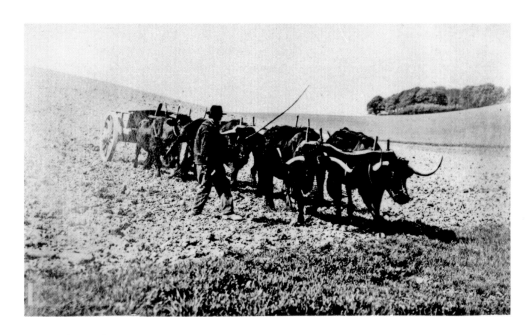

Heavy Livestock

Baldwin and Ridsdale also wrote that 'black oxen with buff-tipped horns used to do the ploughing in our parts ... Two, four, or six oxen drew the plough somewhat quicker than the horse, and they were kept at their work by a goad, made of hazel wood seven or eight feet long ...' Ernest Moppett, for example, worked with oxen for Farmer Brown at Challoners.

Cows meander past Court House, out of sight on the right. In the background is the Hog

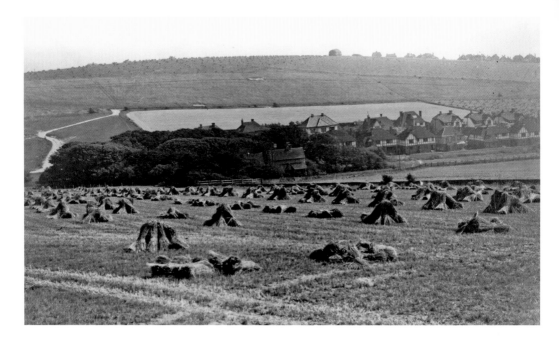

Crops and a Converted Farm

Arable farming has also, of course, always been of importance around the village and beyond. In the valley is Dean Court Road, which rarely features in books on Rottingdean. The track on the left is now Lustrells Road, with housing on part of one side.

On the village's northern extremity stands New Barn Farm, historically in Ovingdean parish. Owned by Brighton and Hove City Council, the farm is today used predominantly as livery stables and is leased to a tenant farmer.

(Inset, Shannon England, aged seven, and friend)

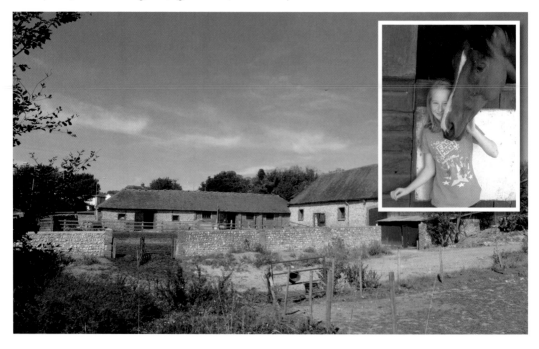

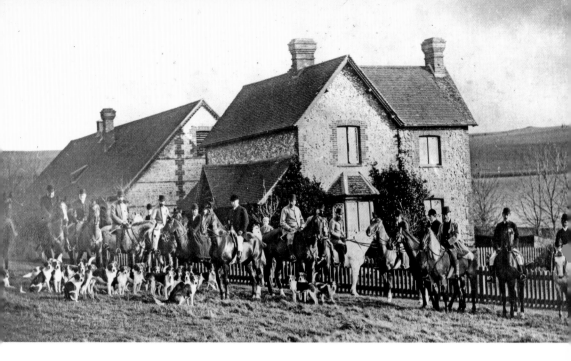

The Kennels

On the previous page (top), the kennels and dwellings associated with, most famously, the Brookside Harriers, can be discerned among the trees. This fine image of the pack and huntsmen dates from 1889. The buildings survive as residential properties in what is now Gorham Avenue, near Dean Court Road. Before their use as kennels (from 1869), they were the isolation unit for sufferers from typhoid and scarlet fever.

An extract from the register entitled *List & Pedigree of the Brookside Harriers, 1834*.

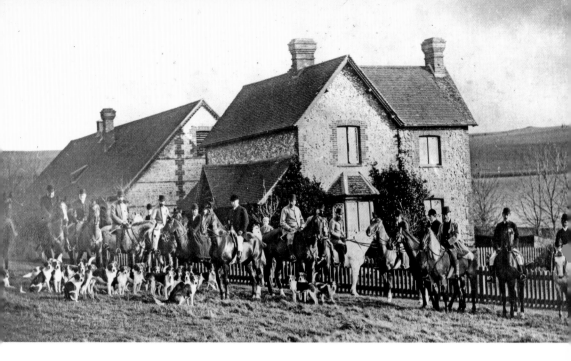

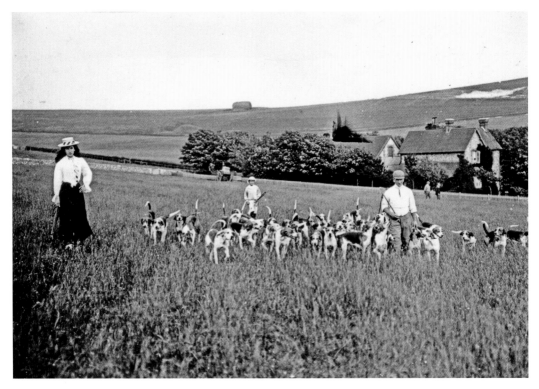

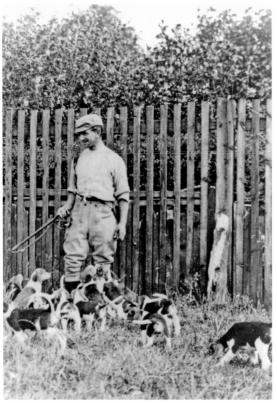

Edmund Funnell and Family
Another view of the kennels and hounds, in the charge of the Funnell family. Left is Maud Alice (1887-1958), centre, her brother Edmund Nelson (1894-1962) and, right, their father Edmund 'John', the huntsman (1864-1922).

In 1915, the hounds were sold to America and Edmund Funnell accompanied them to train them to American conditions, later returning to Rottingdean.

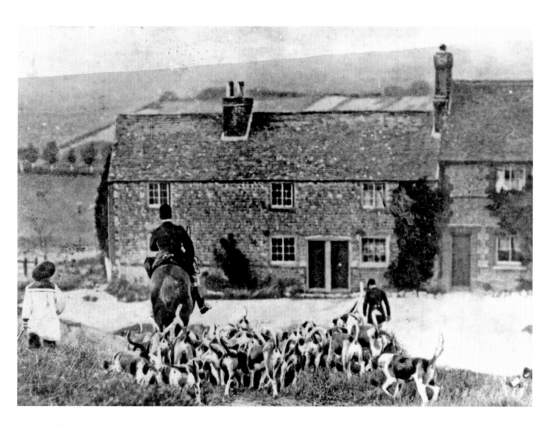

Off to the Meet
On Boxing Day 1901, the huntsman and hounds descend Bazehill Road, approaching Northgate Cottages on the Falmer Road.

The Meet outside Challoners, with Rottingdean Preparatory School in the background.

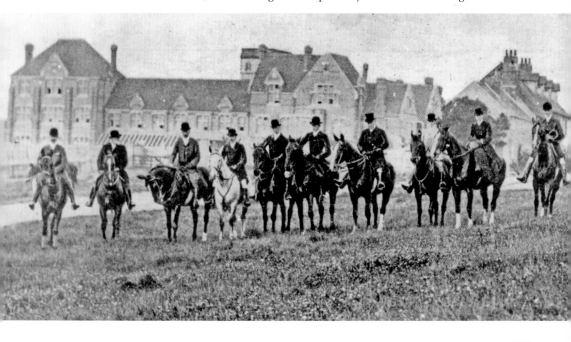

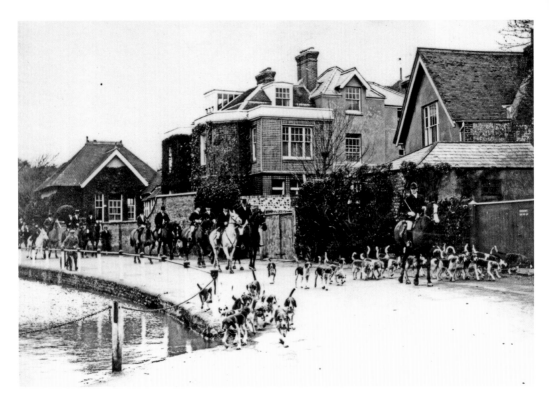

The Southdown Hunt

Dalgety the Master leads the Southdown Hunt past the pond. In the background, from left to right, are St Margaret's Cottage, Norton House and Norton Cottage.

A Meet of the Southdown Hunt on The Green. Mounted is the Master, Arthur Dalgety, and on the right is Ernest Beard (1873-1959), one of the last major private landowners in Rottingdean.

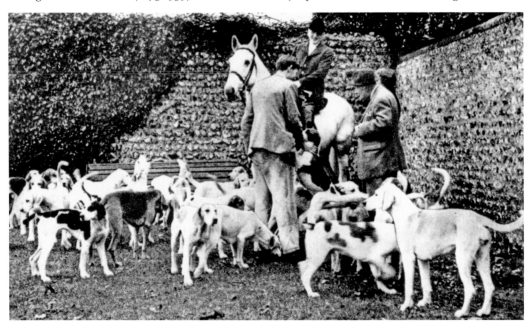

Artists' Impressions

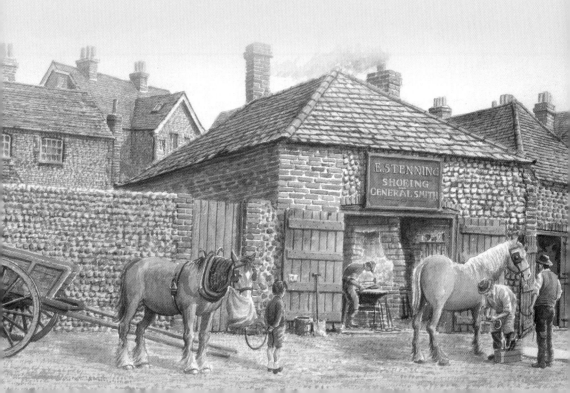

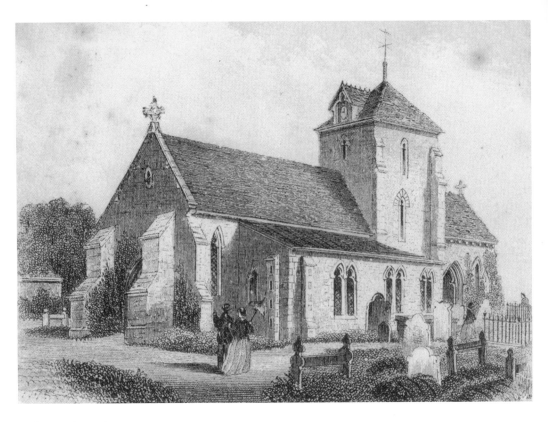

Mid-Victorian Prints

The previous page features work by local artist Mick Bensley. His study of the old forge nicely complements the upper image on page 56.

These early prints are well known to local historians and collectors and are steel engravings by Newman & Co. of Railway Street, London. They date from around 1860. A complete set with this pair and some less common views of the village is contained in a booklet entitled *Six Views of Rottingdean and its Neighbourhood*, published when new by H. Tuppen of Rottingdean.

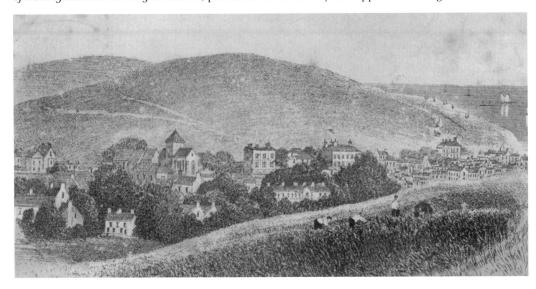

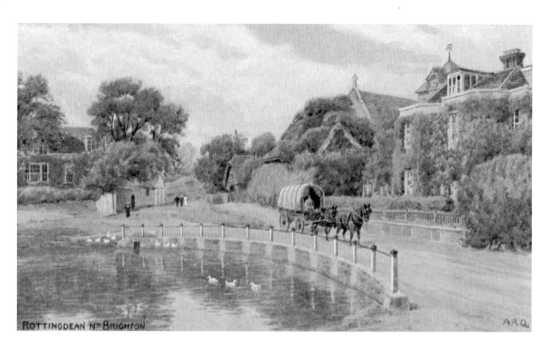

ROTTINGDEAN Nr BRIGHTON A R Q

Pond idyll and North End House

The tranquillity of Rottingdean around a century ago as captured by Alfred Robert Quinton (1853-1934), an English watercolour artist known for his paintings of British villages and landscapes. Well over 2,000 of Quinton's paintings were printed between 1904 and the time of his death. Many, like this one, were published as postcards by Salmon of Sevenoaks. The Elms is on the left and the tower of St Margaret's church on the right.

North End House from the back. Painted in 1945 by Enid Bagnold. (Courtesy Comtesse Laurian d'Harcourt)

Philip Burne-Jones

Philip Burne-Jones (1861-1926) was the first child of Sir Edward Burne-Jones. In this charming study, on which is written *ROTTINGDEAN Aug. 1897*, he portrays his young nieces, Clare and Angela Mackail, probably at High Barn. Angela went on to become the novelist Angela Thirkell. In *Three Houses* (1931) she recalls happy childhood days in Rottingdean.

This beach scene, on which is written 'The House the Sea eats', dates from 1882 and was given to Enid Bagnold by Mrs Ernest Beard. (Both courtesy Countess Laurian d'Harcourt)

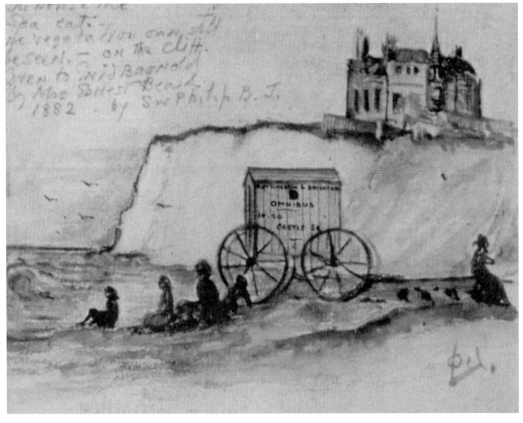

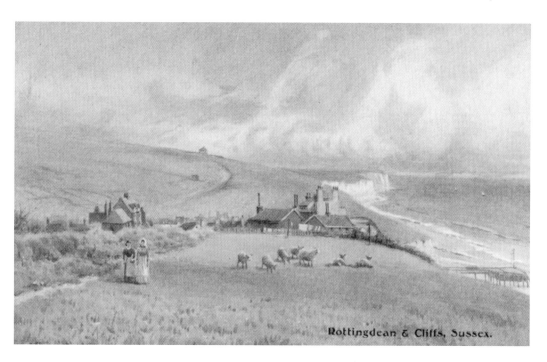

Rottingdean & Cliffs, Sussex.

Clifftop and Green

In this rural idyll, on which the artist's name is indistinct, the clifftop is far wider than today. The twin chimney stacks belong to Cliff House. In the distance, the coast road curves gently towards Saltdean. Since the pier is visible, the scene must date from after 1896.

The heart of the village is evocatively portrayed in this water-colour drawing by the prolific W. H. Borrow. The downs behind the church seem to have been given considerable extra height.

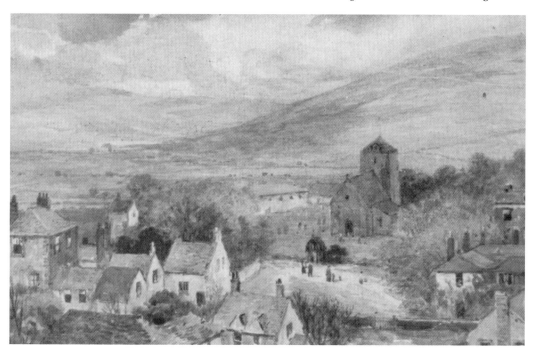

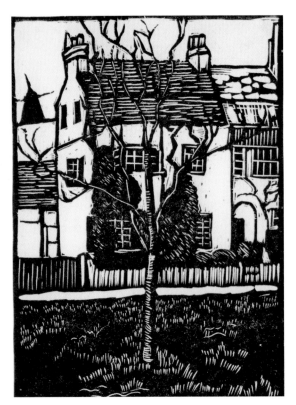

A Contrast in Styles

The young tree in the foreground in this striking representation, captioned 'Burne Jones's House, Rottingdean' and initialled 'D ME', dates the drawing to the early 1930s – see the postcard on page 43, sent in 1934. It has since been removed.

This westward view of 1914 by Charles Ginner (1878-1952) is currently on sale as a card in the village. Cliffe House stands out, as do the backs of the properties in Manor Terrace and the row of properties in West Street. (Courtesy Worthing Borough Council)

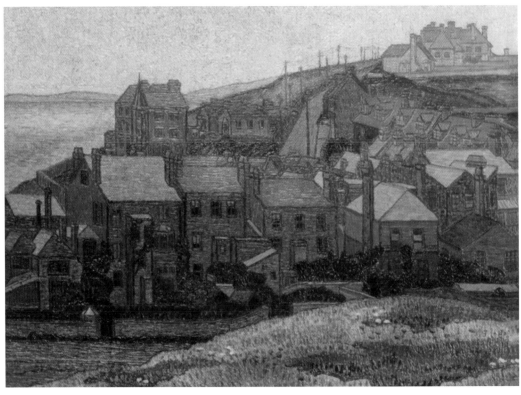

A Tudor Corner and a Foreshore Scene

In the same style as the drawing of North End House on the previous page is this attractive depiction of part of Tudor Close. No artist's name is given. The fact that the title refers to the 'Close' and not the 'Hotel' rules out most of the 1930s for its date.

W. H. Borrow has again taken some artistic licence here, this time with the height of the land and cliffs behind the buildings. The steps, too, seem wider than they actually are. The overall picture is, however, pleasing. The postcard was sent on 19 August 1913.

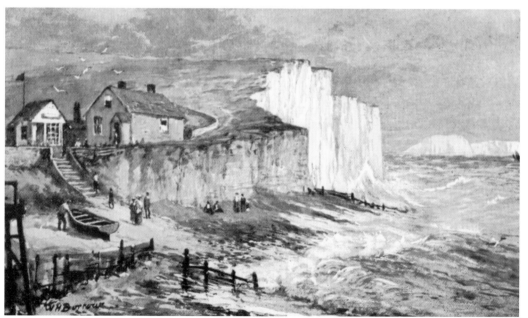

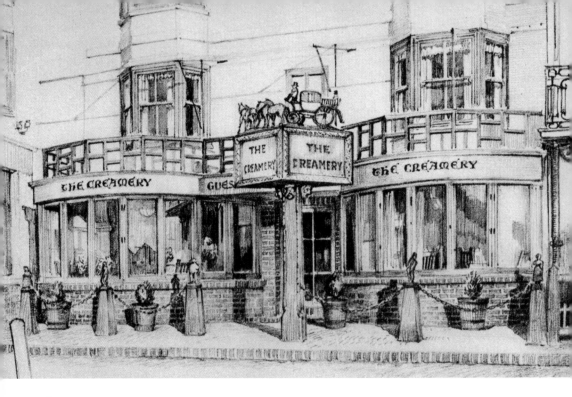

The Creamery

The Creamery was built in 1745, actually as a creamery. It is recorded as trading under that name as a guest house and café from 1895, continuing to do so for the best part of a century. Now the Coach House public house, it was previously a bar/restaurant trading as the Coach and Horses Restaurant, established by well-known entertainers Margo Henderson and her husband Sam (Somme) Kemp, both of whom died within days of each other in the summer of 2009.

These attractive drawings were published as publicity postcards by the Creamery's proprietor.

chapter 10

General Views

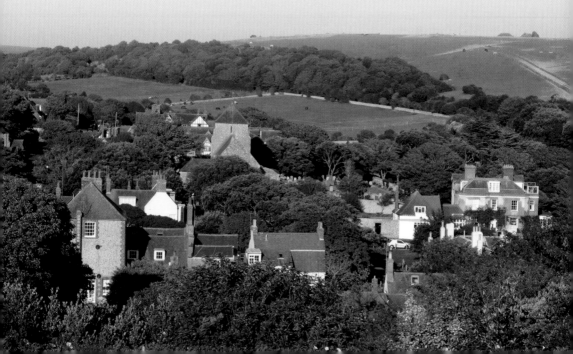

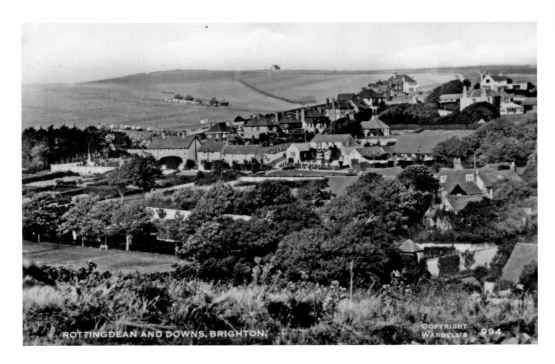

ROTTINGDEAN AND DOWNS, BRIGHTON. COPYRIGHT WARDELL'S 994

Distant Bazehill Road (1)

The Falmer Road divides this 1930s scene lengthwise. Most prominent (centre) are the converted farm dwellings, Court Barn, Little Barn and Lanterns, to the left of which are Northgate Cottages and Challoners Cottages. At top right stands Bazehill House, part of which – as Hillcott, now Hill Cottage – would become the residence of the artist Cecil Rochfort D'Oyly-John (1906-1993). Nearby is the lost Northgate House – see page 47.

The tasteful Burnes Vale development dominates the modern picture.

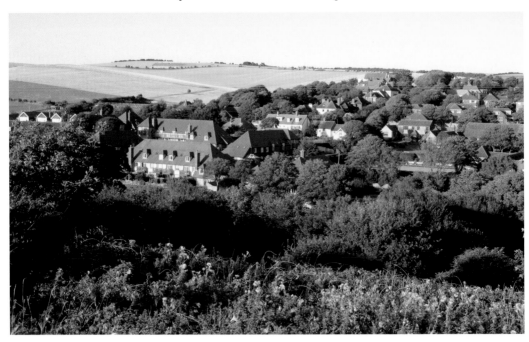

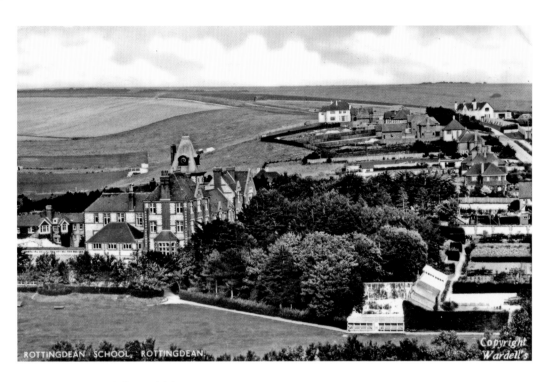

ROTTINGDEAN SCHOOL, ROTTINGDEAN.

Copyright Wardell's

Distant Bazehill Road (2)

Here we have moved a little way to the north, which affords us a splendid view of Rottingdean School, with Bazehill Road on the right. Bazehill House is quite prominent.

The extent of tree growth is again remarkable, although virtually all the conifers which once stood near the school have gone.

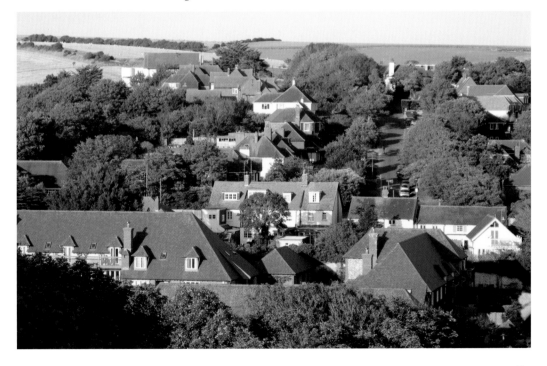

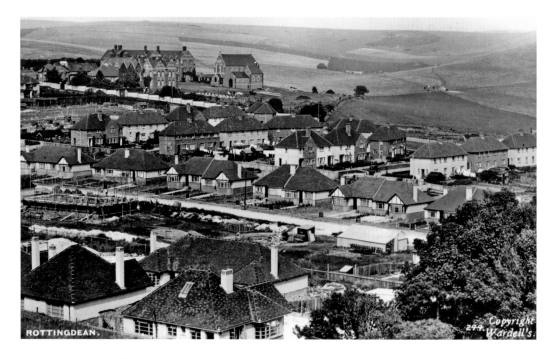

1930s Housing off the Falmer Road

There are a large number of residential properties both north and east of the village. Here Alfred Wardell allows us to see work in progress on the new bungalows in Eley Drive. The property under construction is thought to be Nos 17/19. In the distance stands St Mary's Convent, now the Rottingdean Place apartments.

The cottages in a row on the left (lower view) are Court Ord Cottages of 1896, while in the foreground are houses of Meadow Close.

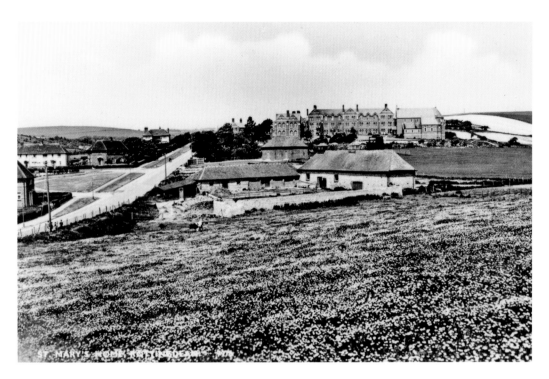

Two Convents

This rare postcard depicts 'St Mary's Home, Rottingdean', erected and dedicated in 1912 as a home for female penitents run by the Community of St Mary. Later known as St Mary's Convent, it is, and always has been, in Ovingdean parish. On the left is the new 1930s housing of New Barn Road/Court Farm Road. The buildings of New Barn Farm show little change today (see p. 72).

An unusual rear-elevation view of St Martha's Convent on The Green, from a postcard sent in 1932.

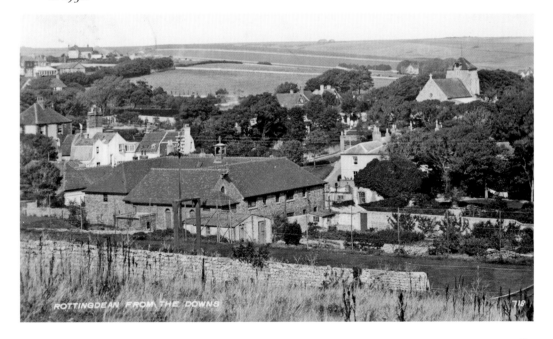

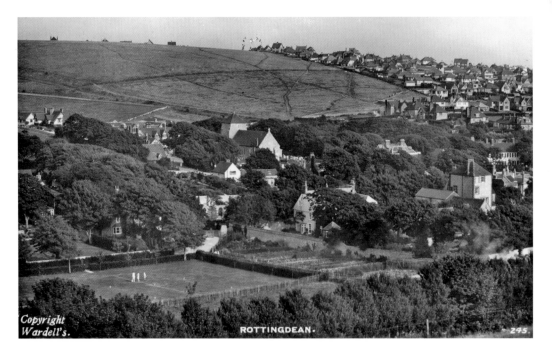

Copyright Wardell's.

ROTTINGDEAN.

245.

South-easterly Prospect

The tree growth is surprisingly abundant in this Wardell postcard of 1930s vintage. The playing field (left) of the lost Preparatory School has survived, next to the Hog Plat allotments. Closer examination reveals The Elms' garden (left of the white-walled outhouse below the church) and Hillside, masked by a tree but with its garden gazebo just visible.

The older panorama boasts plenty of farm buildings with, as yet, little housing on distant Rottingdean Heights.

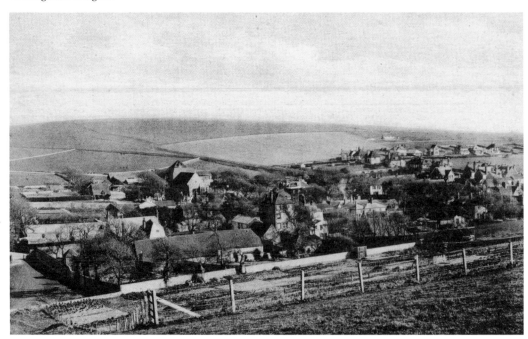

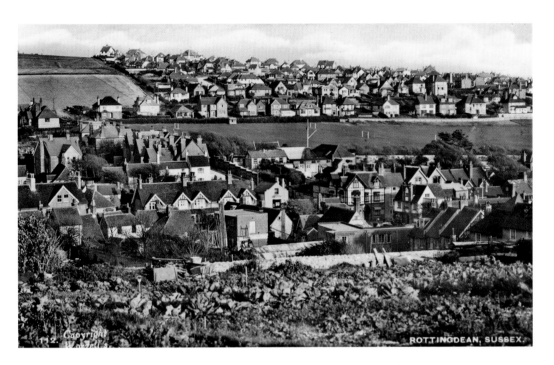

Newlands Road and St Aubyns Playing Field

Another sharp Wardell card of the 1930s has perfectly captured Rottingdean's development. Largely unchanged is the playing field, although its southern portion has been developed (see next page). Running along its eastern boundary (below) are the substantial dwellings of Newlands Road – none more so than the present-day Rottingdean Nursing/Care Home. The earlier photograph reveals that this replaces two former residences.

For its part, the Catholic church of Our Lady of Lourdes, as noted previously, occupies the site of a large garden in Steyning Road.

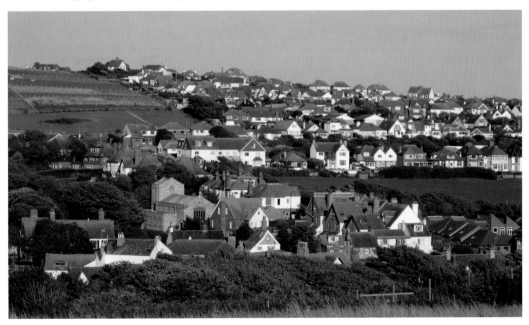

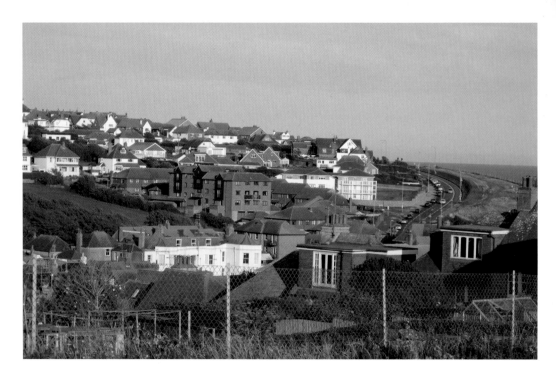

The Sea Again

Here is the extensive St Aubyns Mead development on the playing field (early 1980s) and the recent white/orange Ocean Reach apartments which replaced a luxury 1960s residence on the corner of Newlands Road and the A259. The constant traffic and controversial new bus lane can be clearly seen. St Aubyns School, with its white walls, is also conspicuous.

Brighton photographers, Avery's, produced many local postcards in the early days. This example, showing the school – in a view that cannot be reproduced today – was posted on 3 August 1923.

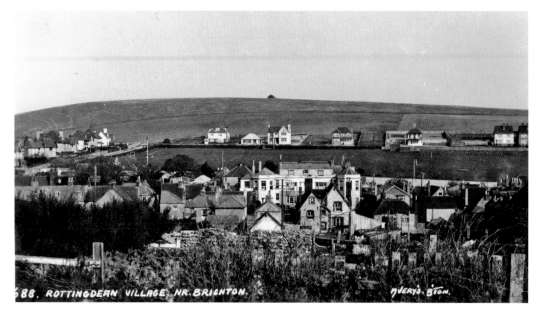

688. ROTTINGDEAN VILLAGE. NR. BRIGHTON. Avery's. B'ton.

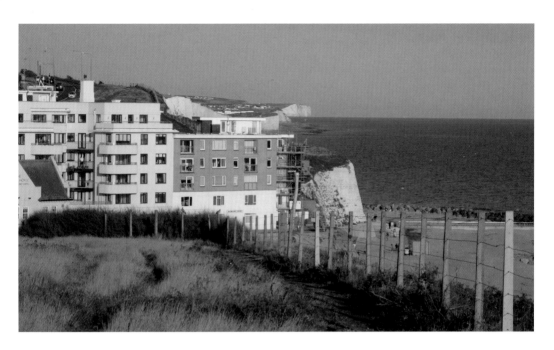

Clifftop Changes

Rottingdean in a coastal context. The moderate height of Highcliff Court allows part of East Saltdean, and the cliffs beyond, to be seen.

Postally used in 1932, this card, by Judges of Hastings, is captioned Rottingdean Heights and shows the new housing on East Hill. The corrugated-iron bungalow on the left can only be the Iron House, listed in *Kelly's Directory* as early as 1895. Work on the new Undercliff Walk is in progress west of The Gap.

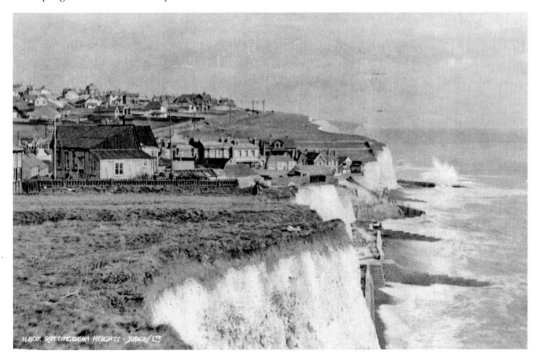

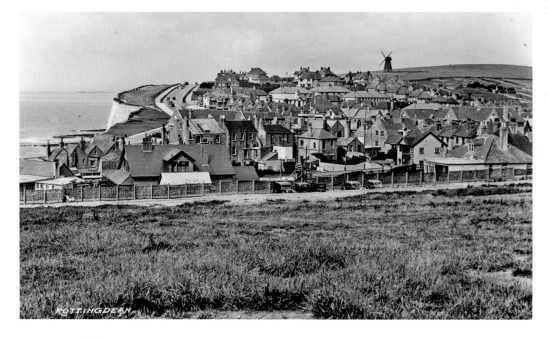

A Westward View Lost

Even Boots the Chemist produced postcards. This sharp, sepia example appears to date from the mid-1930s, as the newly widened coast road can be seen in the distance. Closer examination reveals construction in progress of the unnamed block of flats on Marine Drive today numbered 21-29.

The bungalow at bottom right (No. 36 Marine Drive), now minus its rear dormer window, is common to both pictures, but otherwise St Margaret's and Highcliff Court dominate the rest of the scene.

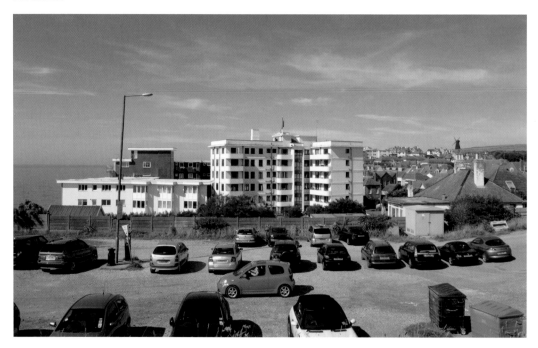

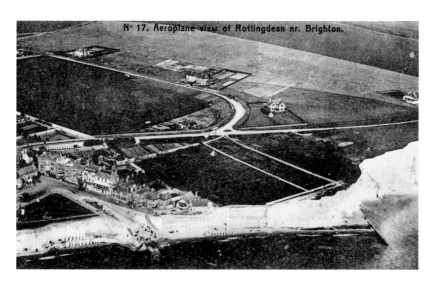

Birds Eye Views

These sepia views of an unusual kind, by Wardell, contrast with each other and dramatically with the contemporary panorama.

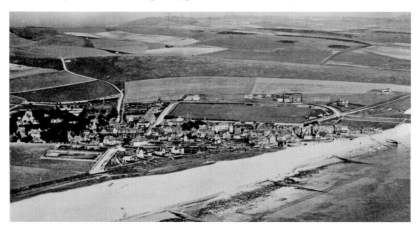

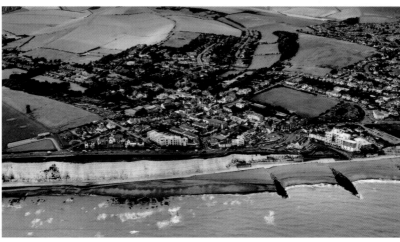

Acknowledgements

I am especially grateful to Daphne Turner for the loan of the late David Baker's collection of Rottingdean images. Brighton historian Chris Horlock donated his entire collection of pictures of the village, while Peter Booth readily lent me all his collection of postcards of this area. I thank Roger Luther for putting me in touch with Amberley Press at the very outset.

I also greatly appreciate the assistance given by: Mick Bensley; Brenda Burnell; Paul Chaloner (of Messrs Adams & Remers); Patrick Collins (National Motor Museum, Beaulieu); John Copper; Jill Dudley (née Copper); Jon Dudley; Sandra Funnell; Comtesse Laurian d'Harcourt; Arthur Hazell; Simon Hitchings (Headmaster, St Aubyns Preparatory and Pre-Preparatory School); Ian Hyder; Lady Helena Hughes (of *Challoners*); Alan Lambert (National Motor Museum, Beaulieu); John Leech (Archivist, Rottingdean Preservation Society); Steve Myall; Carol Plater; Violet Simpson; Joan Snudden; Jackie Sullivan (Archivist, Roedean School); Mike Tucknott; and Chris Wrapson.

Bibliography

The Argus, http://archive.theargus.co.uk/ (newspaper archive from 1998)

Blyth, Henry, *Smugglers' Village – The Story of Rottingdean.* Privately published. (undated; c. 1964)

Carder, Timothy, *The Encyclopedia of Brighton.* Lewes: East Sussex County Libraries, 1990

Coates, Professor Richard, *A Place-Name History of the Parishes of Rottingdean and Ovingdean in Sussex (including Woodingdean and Saltdean),* Nottingham: English Place-Name Society, due 2010

Copper, Bob, *Early To Rise: A Sussex Boyhood.* London: Heinemann, 1976

d'Harcourt, Laurian, *Rottingdean: The Village.* Saltdean: DD Publishing, 2001 (published 2002)

Heater, Derek, *The Remarkable History of Rottingdean.* Brighton: Dyke Publications, 1993

Payne, Tony and Scott, Eddie, *Rottingdean in old picture postcards.* Zaltbommel (Netherlands): European Library, 1985